MW01242722

IMAGES
of America

FLORISSANT

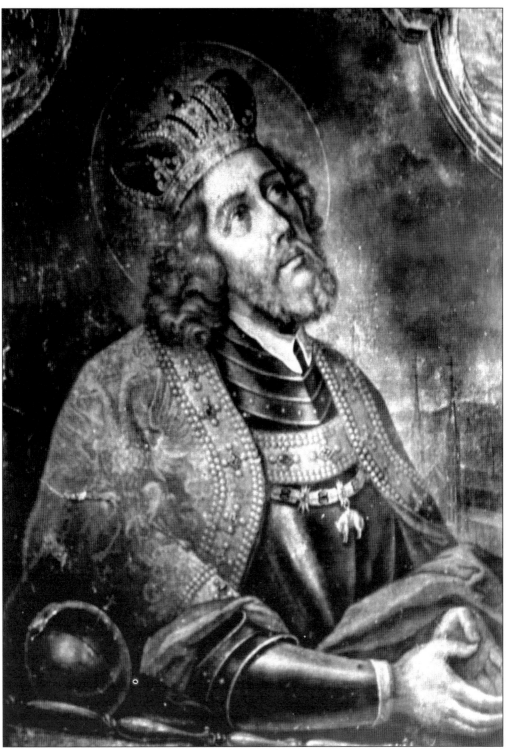

King Ferdinand III of Spain (1199–1252), for whom Saint Ferdinand parish was named, was canonized for driving "the infidel Moors from Spain." (Photo courtesy of the Mercantile Library.)

IMAGES
of America

FLORISSANT

John A. Wright, Sr.

ARCADIA

Published by Arcadia Publishing,
an imprint of Tempus Publishing, Inc.
Charleston SC, Chicago, Portsmouth NH,
San Francisco

Printed in Great Britain.

Library of Congress Catalog Card Number: 2004103257

For all general information contact Arcadia Publishing at:
Telephone 843-853-2070
Fax 843-853-0044
E-Mail sales@arcadiapublishing.com
For customer service and orders:
Toll-Free 1-888-313-2665

Visit us on the internet at http://www.arcadiapublishing.com

(Photo by John A. Wright.)

CONTENTS

ACKNOWLEDGMENTS

I would like give a special word of appreciation to Mayor Robert G. Lowery Sr. for requesting that I write this book. It has indeed been a delightful and rewarding experience. Special appreciation goes out my wife Sylvia who has been with me throughout this project providing assistance, and to Jeri Debo, Patricia Kadlec, Charles Brown, Audrey Newcomer, Jeff Oberither, Rosemary Davison, Maureen Pfeifer, and Nancy Merz for providing invaluable information and for being available for never ending calls for assistance.

Thanks also go to the following individuals and institutions for their help and support in making this book possible. Those individuals are: Chief William G. Karabas, Mark Rowles, Robert Lowery Jr., Chief John Wheadon, Jeff Konkel, Jan Yacovelli, Patrick Boyle, Chris Duggan, Barbara Brain, Patricia Sosa, Bonita Weaver, Kristen Foht, Margaret Cuero, Tina Mueller, James Bartlett, Joyce Rouse, Lori Busby, Barbara and Bill Olwig, Steve Gettermeyer, Tom Dunlap, Jim Babbage, Douglass Kraus, Tina Mueller, John Kohen, Madeline Egeston, Sherry Cypret, Carol Janick, Susan Vitale, Kathi Asikainen, Carl Peters, Gina Siebe, Don Fischer, Jim Shulte, Charleen Sanders, Cathy Aarow, Nicole Whitesell, Susan Lark, Alexandra Gwydir, Edwin Benton, Ron Veach, Harold McClure, Susan Lark, Michael Thacker, Harold F. Ernst, Janice Williams, Gary Meyer, Bob Laramie, Tom Wallace, Gary Gaydos, and Randy Barnes. The institutions are: the City of Florissant, Ferguson–Florissant School District, Hazelwood School District, St. Mark's United Methodist Church, Hendel's Market, Our Lady of Fatima, Mercantile Building, Midwest Jesuit Archives, Parker Road Baptist Church, First Baptist Church of Florissant, John Knox Presbyterian Church, Old Town Partners, The Florissant Police Department, Florissant Street Department, The Florissant Fine Arts Council, The Valley of the Flowers, Florissant Valley Fire Protection District, Florissant Parks and Recreation Department, Missouri Humanities Council, St. Louis County Library, St. Louis Christian College, Special School District of St. Louis County, Mercantile Library, Midwest Jesuit Archives, and Archdiocesan Archives. To those whose names should be included in this list but are not, please forgive me for the oversight. You know who you are and I thank you too.

INTRODUCTION

The City of Florissant, the third oldest city in Missouri, shares the Spanish–French heritage of the Louisiana Territory. It is thought by many to have been settled around 1764, the same time as St. Louis and maybe even earlier. Records show that one Nicholas Herbert dit Lecomte, "alleged earliest settler of the Florissant Valley," is said to have resided in the area as early as 1763. The name Florissant came from early French farmers and fur trappers who settled the area. They called the area "fleurissant" or flowering because of its rich black soil. In 1791, Florissant produced 8,030 pounds of tobacco, nearly as much as the combined output of all other settlements of Upper Louisiana.

The original village was not officially established until 1786, when Captain Francois Dunegant established the first civil government and served as its first military and civil commandant. The village had been laid out in 16 square blocks with most of the streets named after Catholic saints. This original plot forms the heart of the "Old Town" section of Florissant today. At that time the village was known as St. Ferdinand, named in honor of King Ferdinand III of Spain (1199–1255), a name that lasted until 1939, when the city was officially named Florissant.

Though the village bore the name of a Spanish saint for over 150 years, the community was Spanish in name only. French farmers plowed their field, worshipped in their own language, and built homes in French style architecture, with porches and galleries surrounding primarily clapboard houses with open beam ceilings. Today, along streets that bear their original names, examples of French as well as Colonial and German architecture still can be found dating back to the 1700s and 1800s. The old St. Ferdinand Shrine where Father DeSmet, beloved Black Robe missionary of Indian nations, was ordained can also be found, along with the convent wing built in 1819 for Blessed Philippine Rose Duchesne.

During the mid 1800s, German immigrants began to settle in the community at the top of the hill over looking the French settlement along Cold Water Creek. Together with the French they began to develop the city we now know as Florissant.

A year after the village's founding, a Spanish census credited it with "seven plantations of farms and a population of forty persons resident thereon." Although the location proved attractive for a settlement, the community remained small and somewhat isolated.

By 1883, four years after the narrow gauge railroad began operating between Florissant and St. Louis, there were seven general stores, two hotels, and at least eighteen specialty shops and services. The community continued to remain small until after World War II. When the war ended area residents needed homes and Florissant was ready. It had water and the beginning of a sewer system, fire protection, and acres and acres of land surrounding its perimeter. Between 1947 and the mid-1970s, about 18,000 homes were built and by 1980 the population had grown to over 76,000, from 3,737 in 1950. Where once stood crops of wheat and corn now stands

subdivisions, shopping centers, schools, churches, parks, restaurants, and businesses of every description to meet the needs of residents.

Today the community strives to preserve its proud and rich traditions and build on its future. The city operates under a home rule charter adopted by a vote of the people in May of 1963. This is the fourth charter under which Florissant has existed as a municipality. The preceding three charters were granted by the State of Missouri successively in 1829, 1848, and 1857. Under the provisions of this charter, Florissant is governed by a Mayor–Council form of municipal government with a full-time, salaried mayor and nine part-time council members.

Through photographs, this book documents and shares some of the high points in Florissant's outstanding history.

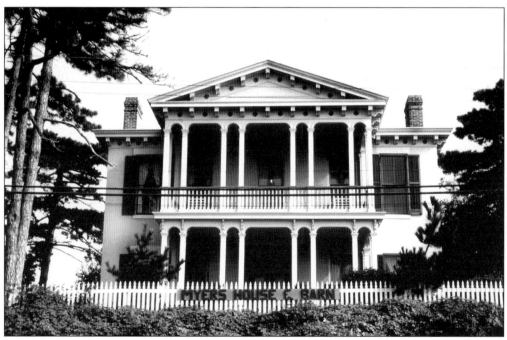

The John B. Myers House (1869–1870), Victorian with Palladian influence, was saved from demolition for the expansion of highway 270 by Historic Florissant, Inc. (Photo courtesy of the Ferguson–Florissant School District.)

One
THE BEGINNING

It is unclear when the first settlers arrived in the city we now know as Florissant. We know that at least ten years before the American Revolutionary War, French colonists had established settlements from New Orleans to Canada along the Mississippi and Missouri Rivers. Two of these settlements were St. Louis and Florissant, Missouri. French farmers and fur trappers moved into this area next to Cold Water Creek in 1767 and stayed to till the rich soil. In 1786, the Village of Florissant was founded while the territory was under Spanish rule. It was that year that Captain Francois Dunegant established the first civil government and served as its first military and civil commandant. (Photo by John A. Wright.)

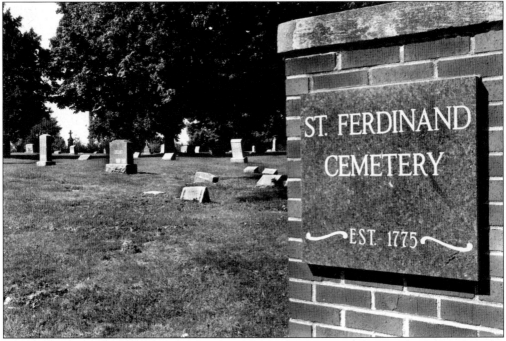

The St. Ferdinand Cemetery west of Graham Road, established in 1775, was a land grant from the Spanish. The remains of a number of early villagers are located here. (Photo by John A. Wright.)

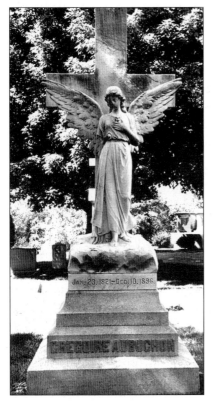

The monument of Gregoire Aubuchon is one of the prominent structures in St. Ferdinand Cemetery. Aubuchon was the first mayor of Florissant under the 1857 charter. It is reported that the early charge for digging graves was $2 for children, $3 for adults buried in ordinary coffins, and $4 for adults buried in caskets. (Photo by John A. Wright.)

This home, known as Taille de Noyer (Walnut Grove), began as a log cabin in 1790 on a Spanish land grant of Hyacinthe Deshetres. John Mullanphy, a prominent St. Louis philanthropist, purchased the cabin in 1805 and for several years used it as a hunting lodge and trading post. He gave the cabin to his daughter, Jane Mullanphy Chambers, as a wedding gift in 1819. The house and the property remained in the family for almost 140 years. During that time it grew from three rooms to twenty-three. It is now the home of the Florissant Valley Historical Society. (Photo courtesy of the Ferguson-Florissant School District.)

John Mullanphy, Missouri's first millionaire and who purchased Taille de Noyer, is credited by some historians as doing more for the St. Louis area than any single individual. His fortune was acquired when he cornered the cotton market after the War of 1812. He offered to build the State Capital at his own expense when Missouri was about to be admitted into the Union—if Florissant was made the state capitol. Mullanphy contributed $1,000 toward the construction of the new Church of St. Ferdinand, and up until the time the building ceased to be a parish church the two front pews were reserved for Mullanphy descendants and mass was said in their names twice a year. (Photo courtesy of the Ferguson–Florissant School District.)

Casa Alvarez at St. Denis and St. Pierre Streets, which was built about 1794 is the only remaining link in the Florissant area to the Spanish. The front portion of the house was built for Eugene Alvarez, military storekeeper for the King of Spain. The house began as a log cabin and was later greatly expanded and covered with siding. (Photo courtesy of Mark Rowel.)

This picture provides a glimpse of how the original interior of Casa Alvarez may have looked as one of the previous owners, the Zimmermans, attempted restoration work. At one time the home was owned by the Archambault family and later by Dr. Herman Schrenk, a famed botanist who developed an extremely fine garden on the property. (Photo courtesy of the Mercantile Library.)

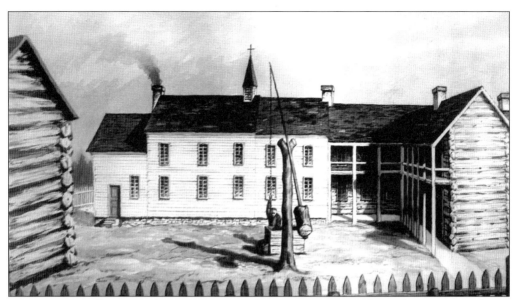

In 1823, a small group of Jesuit priests and seminarians arrived in Florissant and began construction on this log structure, known as St. Regis Indian School. It served Native American children from 1824 until 1831 when it closed. This was the first Catholic Indian School in the United States subsidized by the federal government. An appropriation of $800 per year was allotted for educating whatever number of pupils was admitted. During its existance the school trained 30 Indians. (Photo courtesy of the Midwest Jesuit Archives.)

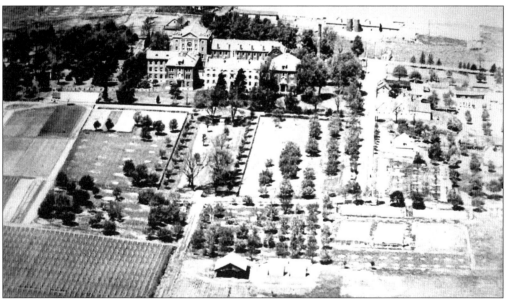

While the Jesuit priests and seminarians were building St. Regis School they were also constructing Stanislaus Seminary at the same location, on a farm owned by Louis W. Valentine Dubourg, bishop of Louisiana and Florida territories. Stanislaus Seminary was the birthplace of St. Louis University. From the seminary's farmland the Jesuits cultivated grapes and operated a winery, which produced DeSmet Wine for sacramental use from the 1820s to the 1950s, along with several other varieties for commercial consumption. (Photo courtesy of the Midwest Jesuit Archives.)

The seminary's first permanent structure, the Rock Building shown here, dates to 1849. It was constructed by the novices, brothers, and six slaves who fired the bricks and carried limestone blocks from the bluffs of the Missouri River nearby. (Photo courtesy of the Midwest Jesuit Archives.)

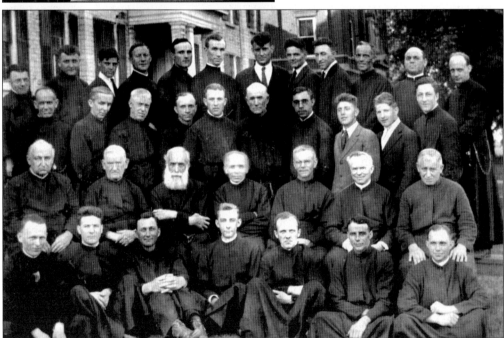

Pictured in front of the Rock Building is one of the early classes of priests, trained at St. Stanislaus Seminary. The seminary closed in 1971 and the buildings and property were sold to Gateway College of Evangelism. Some of the furnishings and artifacts made by the novices and used in the seminary since the 1850s can be found at St. Ferdinand Shrine in Old Town Florissant. (Photo courtesy of St. Ferdinand Shrine.)

Rose Philippine Duchesne established the first Catholic school for Indian girls in the United States in 1825. The school only lasted a few years because of the federal government's refusal to appropriate funds for female Indian education. She also established the first novitiate for women in all the Upper Louisiana Territory. She moved into the brick convent below, which was near the log cabin church of St. Ferdinand, on Christmas Eve of 1819. Her life became a model for the entire order, which now operates schools throughout the world, including Villa Duchesne in Frontenac. (Photo courtesy of the St. Louis Archdiocese Archives.)

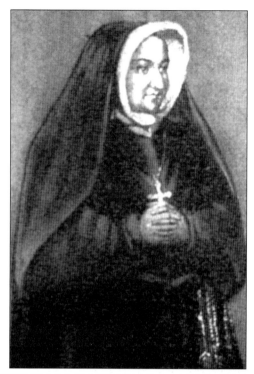

This convent that was built for Mother Rose Philippine Duchesne, in 1819, is the first structure west of the Mississippi River in the Federal architectural style, according to some historians. It became the Mother House of the Sisters of the Sacred Heart, the first of the order to be established outside of France. The Sisters moved from the convent in 1846, and the Sisters of Loretto took up residence there the following year. (Photo by John A. Wright.)

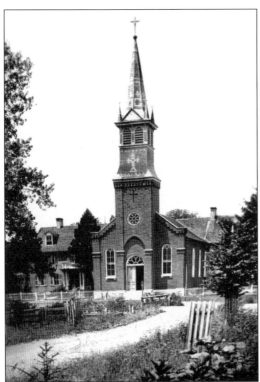

In 1789, the year George Washington became president, St. Ferdinand Church was built in Florissant. The corner stone was a gift from Philippine Rose Duchesne. The church was originally a log structure, which was then replaced by the building shown here. St. Ferdinand Church is the oldest Catholic church between the Mississippi River and the Rocky Mountains. It was originally Federal in style, but assumed its present Italian Romanesque Revival character when it was enlarged between 1877 and 1884. The famed explorer William Clark attended the wedding of the granddaughter of John Mullanphy here. (Photo courtesy of the Midwest Jesuit Archives.)

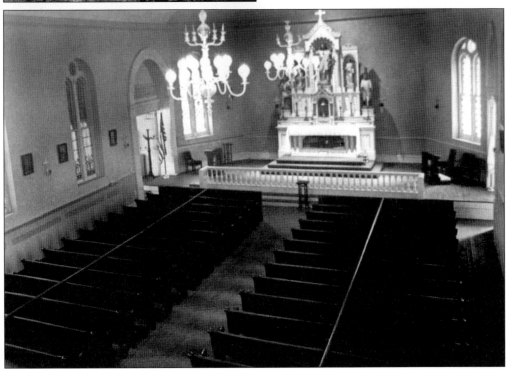

Pictured here is an inside view of St. Ferdinand Shrine. Beneath the alter lie relics of St. Valentine, enshrined in a life-sized waxen figure. (Photo courtesy of the Midwest Jesuit Archives.)

On September 23, 1827, Pierre Jean DeSmet was ordained at the Church of St. Ferdinand and began the work that was to carry him over 188,000 miles on foot and horseback, ministering, converting, and negotiating peace with Indian tribes. He made nine voyages to Europe to recruit men for Indian missions. DeSmet, called the "Black Robe" and highly regarded by the Indians, was very instrumental in making peace between them and the United States Government. (Photo courtesy of the Midwest Jesuit Archives.)

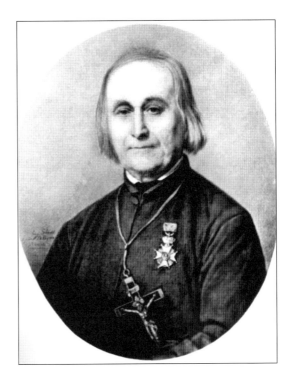

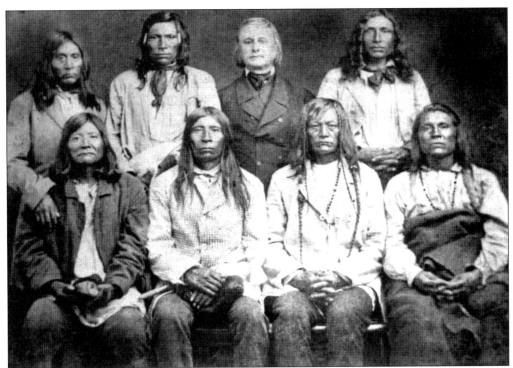

Father DeSmet is pictured here with Chiefs at Fort Vancouver in 1859. At the urging of the Jesuit missionaries, most of the eastern Plateau tribes remained aloof from the Plateau War of 1859. (Photo courtesy of the Midwest Jesuit Archives.)

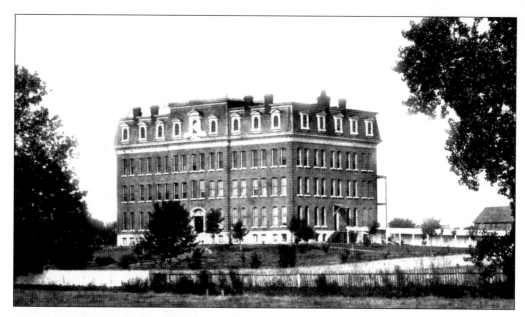

In 1880, Mother Anne Joseph Mattingly S.L. began building a new Loretto Academy after a ten-year assignment in Florissant. It was a four-story brick structure 120 x 80 feet at Washington and St. Charles with steam heat, gas, and hot water. Records show it contained an elegant chapel, parlors, various recitation rooms and music rooms, a commodious study hall and refectory, and two recreation halls for seniors and juniors. Board and tuition at the school was $100, violin, guitar, and piano lessons $30, vocal music $20, expression $30, embroidery $5, library $1, sodality $1, and laundry $5. The school burned down in 1919 and a decision was made not to rebuild because Florissant had only a volunteer fire department which proved inadequate. The Sisters of Loretto, who came to Florissant in 1847, moved to Webster Groves. (Top photo courtesy of the Ferguson–Florissant School District, bottom photo courtesy of Midwest Jesuit Archives.)

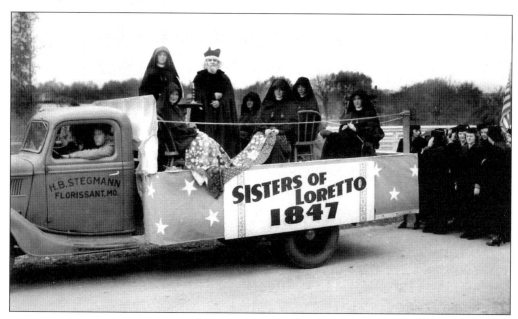

St. Ferdinand Public School, which was located on the present Combs Elementary School site, was constructed in 1876 and operated by the Sisters of Loretto. It was semi-religious in the sense that many of the students, as well as the teachers, were Catholic. This was not unusual, but rather a common occurrence where high proportions of the populations were Catholic. However, it is believed that in 1887 the school board attempted to get rid of the Sisters by requesting they answer a "series of pettifogging and unduly rigorous questions." When the sisters refused to answer the questions the board refused to issue them a teaching certificate. (Photo courtesy of Combs School.)

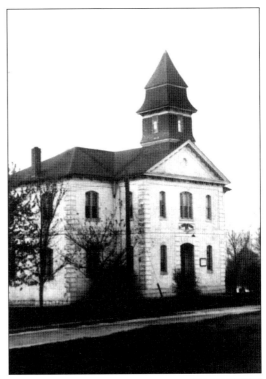

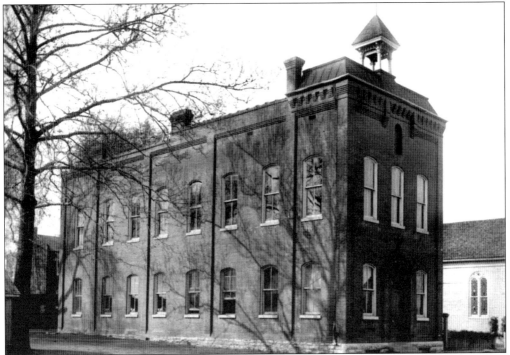

After the sisters left St. Ferdinand Public School they worked to establish the St. Ferdinand Parish School, which opened in 1887. The school started as a one-story facility, the second floor was added later. (Photo courtesy of the Midwest Jesuit Archives.)

Some members of an early class at St. Ferdinand Parish School are pictured outside the school. (Photo courtesy of the City of Florissant.)

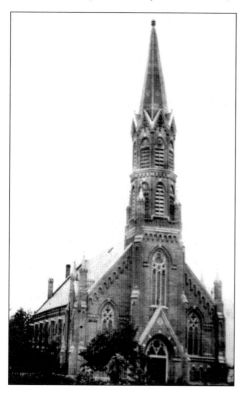

In 1846, a few German Catholic families had settled in Florissant and the surrounding valley, and worshipped at St. Ferdinand's Church, founded by French Catholics in 1789. By 1866 their population had grown to 35 families, and they began to discuss having their own parish and school where their native tongue would be spoken. They petitioned the Most Reverend Peter R. Kenrick, Archbishop of St. Louis, and Very Reverend Ferdinand Coosmans, S.J., for permission to establish a parish where German would be spoken and it was granted. (Photo courtesy of the Midwest Jesuit Archives.)

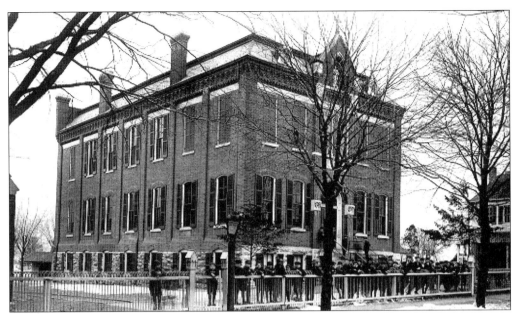

The first two-story school building of the Sacred Heart Parish School was constructed in 1866 was a 33 x 42 foot brick building. The upper floor was a convent, the lower floor contained two classrooms as well as a small parlor and entrance hall. The school was staffed by the Sisters of St. Joseph. When the school fell into poor condition it was replaced with the building shown here in 1889. (Photo courtesy of the City of Florissant.)

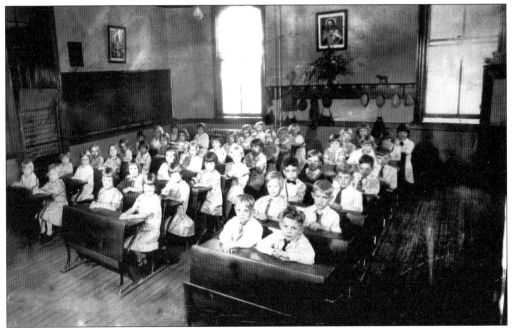

A 1931–1932 Sacred Heart Parish School classroom is pictured here. Early students were taught Catechism, bible history, writing, and Ciphering in addition to the core curriculum. Classes were taught in English half the day and the other half of the day in German. (Photo courtesy of the City of Florissant.)

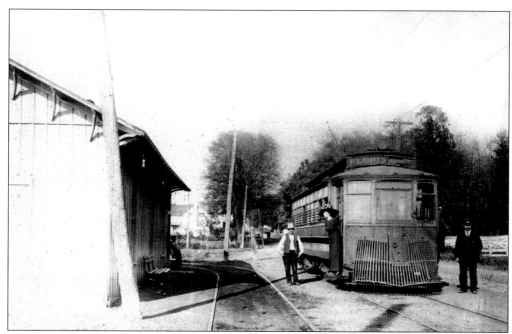

The Western Narrow Gauge Railroad Station opened for business in Florissant on October 1, 1878. The eight-mile section from Normandy to Florissant had been delayed by labor shortage and heavy rains and was finally completed when the City of Florissant offered a bonus of $10,000, with an additional $5,000 subscribed by citizens if the route was completed by October 1, 1878. The train made the trip from St. Louis to Florissant in one hour, gathering steam to reach 25 mph. The train ran until November 14, 1931, when it made its last run to Florissant. (Photo courtesy of the City of Florissant.)

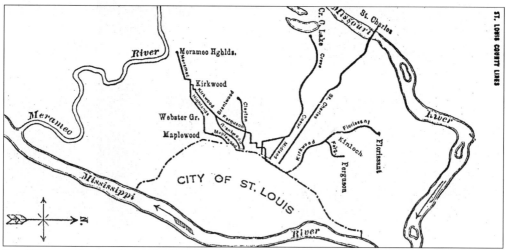

The Western Narrow Gauge Railroad made it possible for Florissant residents to travel to a large part of the county with ease. However, the trip was not always easy. There were days when the train hopped the tracks or a cow had to be moved off the track. In 1888, 27 daily trains were operating from St. Louis and the fares, as published in *The Republic*, were 5¢ from St. Louis to Kingshighway, 10¢ DeHodiamont, 35¢ Normandy, and 50¢ Florissant. (Train route courtesy of John A. Wright.)

Two
SCENES OF
EARLY FLORISSANT

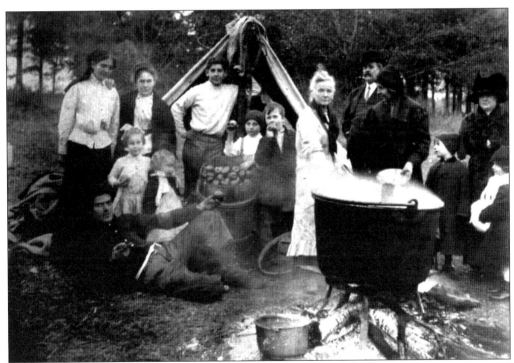

From the founding of the village until the mid-1950s, the pace of Florissant remained slow and rural in character. The 1880 census showed the city with a population of 817, with six general stores, two hotels, three wagon shops, a shoe factory, and various other businesses. It is believed Pierre Chouteau had the first business in town, a log cabin in the 500 block of St. Francois Street, which stood until 1911. These early families are engaged in making apple butter, a long standing harvest-time tradition, along with canning and preserving produce. (Photo courtesy of Hendel's Market Café.)

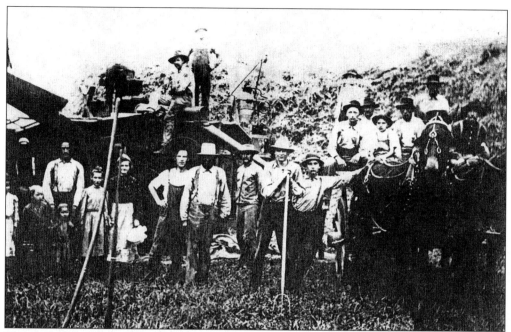

Threshing day was an early village activity that involved the whole family and required as many hands as possible. (Photo courtesy of the City of Florissant.)

The St. Ferdinand Milling Company, which opened in 1895 and specialized in "bolted corn meal," was located near Elk Spring at rue St. Jacques and rue St. Francois. The spring in the block was utilized for running the mill. It was operated by Sidney R. Garrett, one of the founders of the Florissant volunteer fire department and Mayor of Florissant from 1915 to 1928. (Photo courtesy of the City of Florissant.)

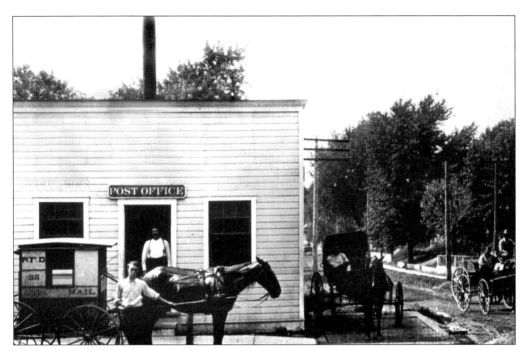

The Florissant Post Office, operated by postmaster Sidney R. Garrett, was an annex of the St. Ferdinand Milling Company facing rue St. Jacques. After the Railway Post Office service was authorized in 1891, a letter could be mailed in Florissant and be delivered in St. Louis in the afternoon. Residents living in town picked up their mail while those in the country had theirs delivered. (Photo courtesy of the City of Florissant.)

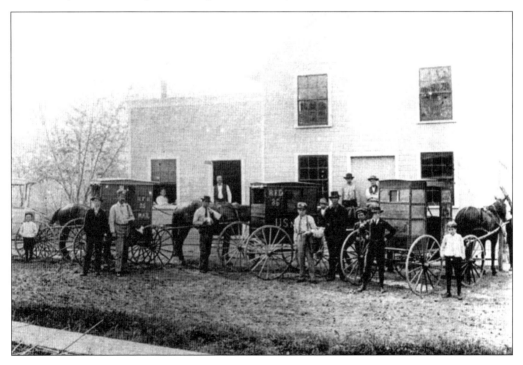

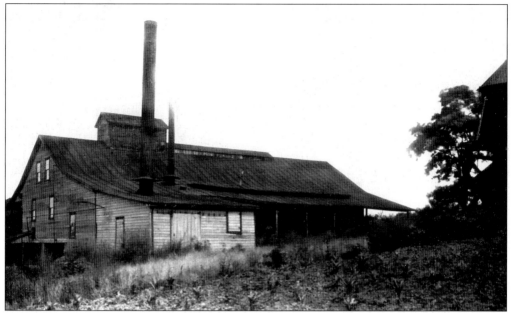

Before closing in 1918, this canning factory at rue St. Denis and rue St Charles Streets won an award at the 1904 World's Fair under the "American" label for its superior tomatoes, grown in the rich soil of the city. The water used at the factory came from the spring in the lower part of the town. During the World War I, when prices soared, the factory discontinued operating because it found it hard to make a profit. (Photo courtesy of the Ferguson–Florissant School District.)

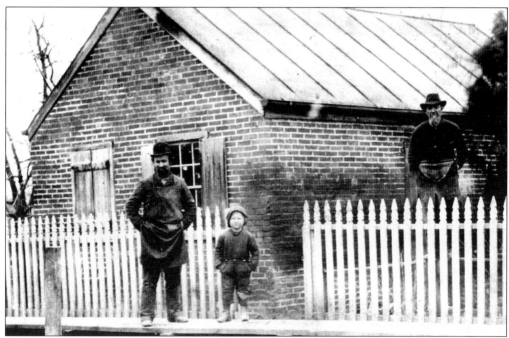

Franz Kienstra, a coppersmith, purchased this shop for $450 in 1857. From his home and shop he made copper pans and cooking utensils, which he then sold in the area from a horse drawn wagon. His family occupied the home until 1938. (Photo courtesy of the City of Florissant.)

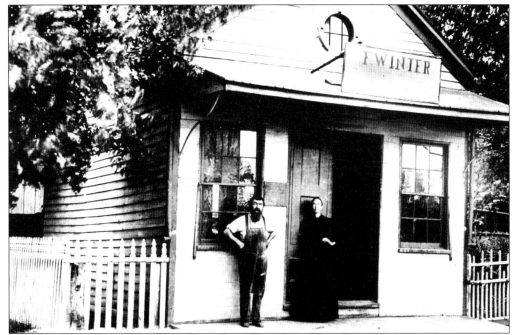

Frank and Margaret Keeven Winter, the parents of former Mayor Bernard Winter, are shown here in front of their boot and shoe shop next to their home at the corner of rue St. Francois and Jefferson Streets. Bernard Winter served as mayor from 1937 to 1938 and was one of 11 children. (Photo courtesy of the City of Florissant.)

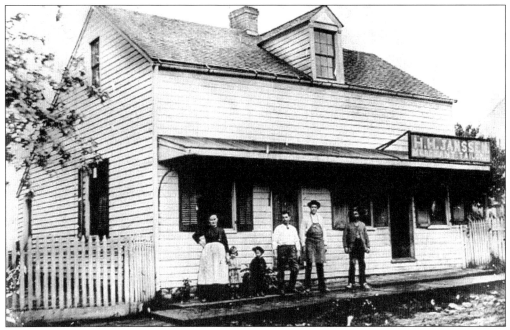

This pre-civil war structure was the home and tailor shop of H.H. Janssen and his family. It was located on rue St. Denis just west of Hendel's market. The structure was destroyed in 1970 to make way for a new home. (Photo courtesy of the City of Florissant.)

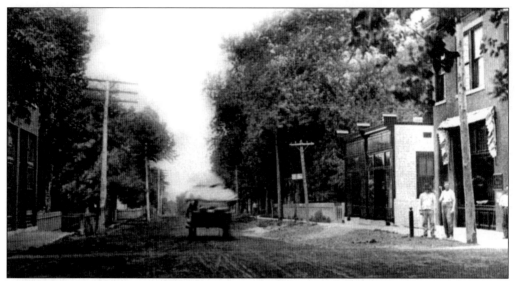

Although the little Village of Florissant was somewhat removed from St. Louis, travel between the two communities was fairly constant. In the early development of the area the Spanish colonials laid out a road between the area of St. Charles and the St. Louis stockade across the Grand Prairie. One of the spurs from this road went to St. Ferdinand de Florissant. This street, rue St. Francois, flowed into the Florissant Branch of that road, which terminated on the Missouri River at a ferry landing. This picture shows rue St. Francois looking west at Lafayette Street. Citizens Bank can be seen on the right. (Photo courtesy of Hendel's Market.)

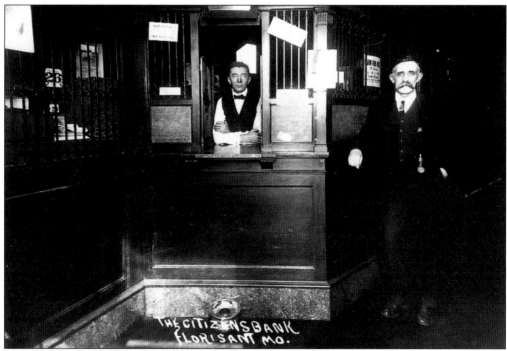

The interior of Citizens Bank is shown here with two of the bank officials. (Photo courtesy of the City of Florissant.)

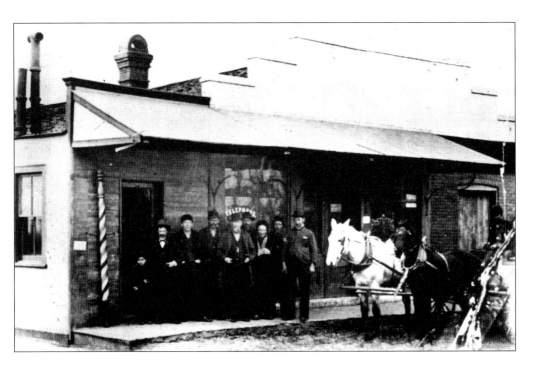

This building belonged to John Wiethaupt, the former president of Citizens Bank and city post master in 1889. John took over his father's business in 1893 and added to the building a cast iron front and second story for living quarters, as shown below. At the back of the store he operated an icehouse with ice taken from the river, stored between layers of sawdust, and sold during the summer. The original one-story building was home to a barbershop, post office, and the location of the city's first telephone, which was available to the public. (Top photo courtesy of the City of Florissant and bottom photo courtesy of Dooley's Florist.)

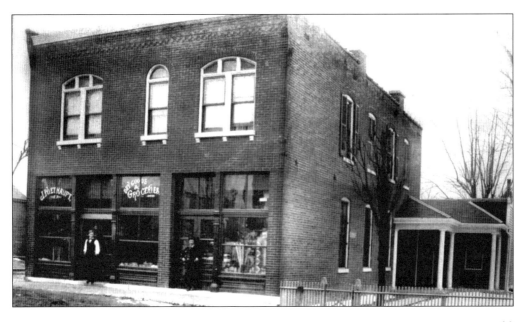

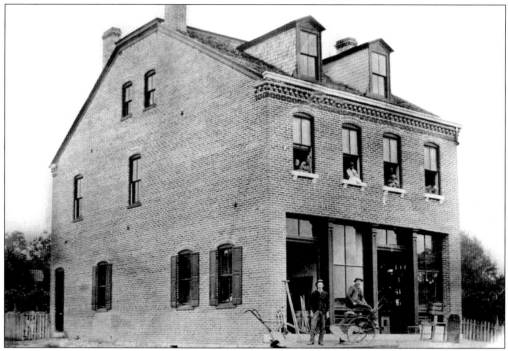

Henry Albers, a German immigrant, opened a store in this building at St. Pierre and St. Francois in 1866. The building was purchased by Historic Florissant, Inc. in 1998 to prevent its demolition. (Photo courtesy of the Ferguson–Florissant School District.)

Henry Albers sold shoes and fabric on one side of the building and his brother August sold hardware and farm implements on the other. (Photo courtesy of Barbara and Bill Olwig.)

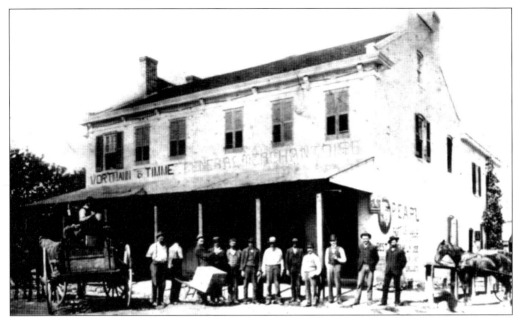

Nicholas Hendel Sr. opened a grocery and butcher shop in this building, at 599 rue St. Denis. It was constructed by Henry Bockrath in 1873. After Nicholas' death in 1936, his wife Bertha kept the store open until 1943, when World War II interfered with its operation. After Henry Hendel Jr. returned from the war, he and his new bride, Margaret Mary Ebbesmeyer, reopened the store in 1945. The building was sold to Edward Bennett in 1993 and he converted it into Hendel's Market Café. (Photo courtesy of the City of Florissant.)

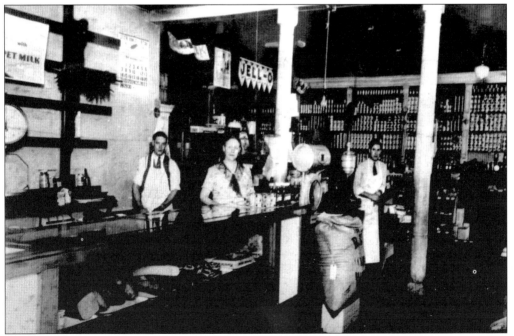

Nicholas Hendel Jr., his mother Bertha, and Henry Hendel are pictured inside the store after Nicholas Sr.'s death in 1936. (Photo courtesy of the City of Florissant.)

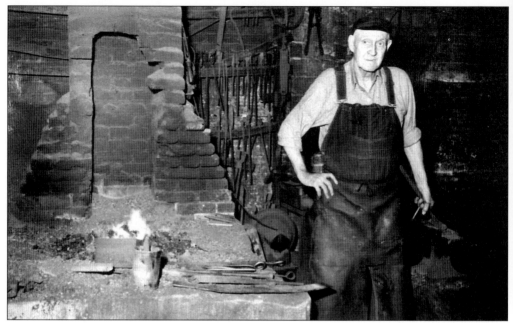

Because horses were used for travel and work, it was essential that the town have a blacksmith shop. John H. Zoeller, Florissant's last blacksmith, worked until the 1950s in his shop in the 300 block of rue St. Francois, which he took over from John Moynihan in 1923. (Photo courtesy of the Ferguson–Florissant School District.)

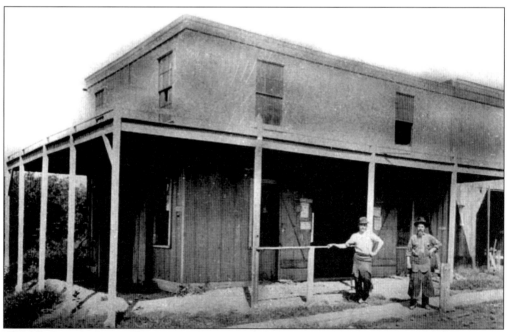

This blacksmith shop at the corner of St. Francois and Jefferson was operated by Charles Craft. Craft served as mayor in 1897 to finish the unexpired term of Joseph Peters, who resigned. After the Union Church was built on this site, Craft moved his shop to the corner of St. Francois and Jefferson. (Photo courtesy of the City of Florissant.)

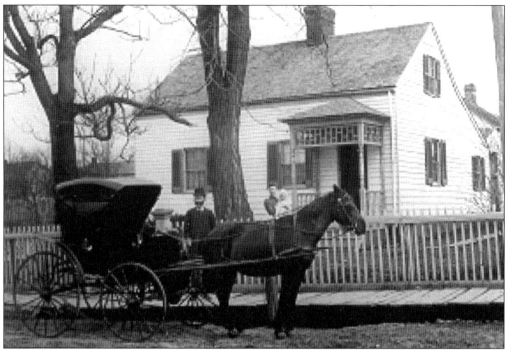

Dr. George LeHoullier, pictured here, was considered a real country doctor by some. He took on the troubles of his patients and helped when he could. LeHoullier was the resident physician for St. Stanislaus Seminary and Loretto Academy, and one of the organizers of the first bank in Florissant. (Photo courtesy of the City of Florissant.)

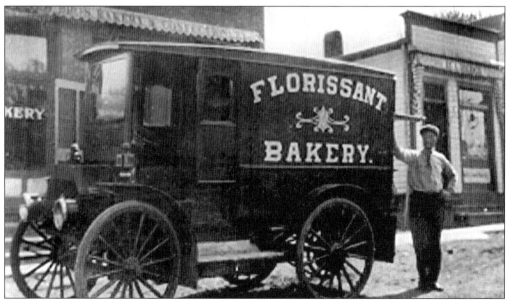

With the coming of the automobile came the delivery of goods and groceries by motor. This is a photograph of an early bakery truck, with the bakery in the background built by Dr. George LeHoullier next to his home on the corner of rue St. Francois and rue St. Jean. The home was demolished but the bakery building still stands. (Photo courtesy of the City of Florissant.)

When the automobile came to the area Florissant roads may not have been fully ready, but William Albers was. Pictured here is his station and garage in the 200 block of rue St. Francois. (Photo courtesy of the City of Florissant.)

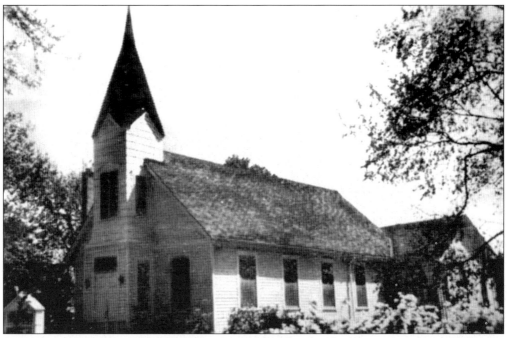

A familiar site at 646 rue St. Francois is the Union Church, which was erected in 1895 for the use of all the Protestants of the town, but particularly the Baptist, Methodist, and Presbyterian denominations. In 1948, Florissant Presbyterian Church purchased the interest from the Baptists and Methodists for $1,067.67 each, and this became the Presbyterian's exclusive home until they moved to their present location at 660 Charbonier Road on November 30, 1958. (Photo courtesy of the Ferguson–Florissant School District.)

The Round Hall in Delisle Park, located at the foot of rue St. Francois, was the scene of most of the social life of early Florissant. The Pancake Ball on Shrove Tuesday and the New Year's Ball were held at the hall. It is reported that for $1.50 one could eat all the pancakes you wanted. The park was also the location of the mail carriers' and firemen's picnics. (Photo courtesy of the City of Florissant.)

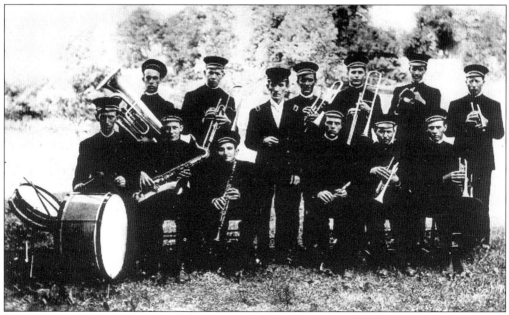

No town would be complete without a hometown band. These are members of an early Florissant band. They are, from left to right: (first row) John Drumer, Leon Albers, Ernest Becker, bandmaster's name unknown, Joe Peters, Tony Gettemeyer, and John Behlmann; (second Row) Smith Castello, Herman Keeven, Louis Creely, George Gouineger, George Otten, and John Stroer. (Photo courtesy of the City of Florissant.)

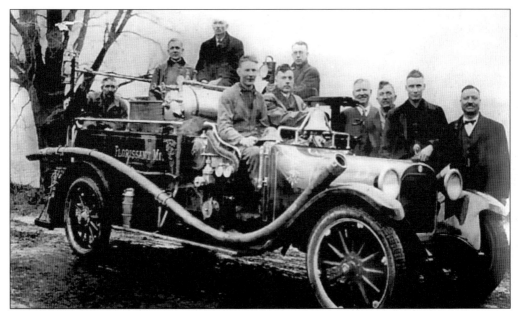

After the Loretto Academy was destroyed by fire in 1919, Mayor Sidney Garrett met with other interested citizens and held an organized meeting for fire prevention. A fire truck was purchased with full equipment. The first fire truck of the Florissant Valley Fire Department is pictured here with, from left to right, Jack Miller, Leonard Albers, Julius Reeb, William Albers, Oscar Aydt Sr., Smith Castello, Joseph Moeller, Bernard Winter, Joseph Richter, and Sidney R. Garrett. (Photo courtesy of the City of Florissant.)

An addition was added to Florissant City Hall to serve as a fire house after the formation of the Fire Prevention Committee. The church bell warning that was formerly used to alert citizens was replaced with a siren installed at the fire house to alert the firemen. The areas outside of Florissant were served whenever possible. Financial subscriptions were solicited by members, and by 1919 a sum of $4,666 had been collected and Mr. Oscar O. Aydt was appointed the first Fire Chief of twenty selected volunteers. (Photo courtesy of the City of Florissant.)

By 1932, the need for a new hose and truck for the Fire Department became evident and it was decided to sell fire tags in the district. Only those purchasing fire tags could expect the firemen to respond to a fire call. (Photo courtesy of the City of Florissant.)

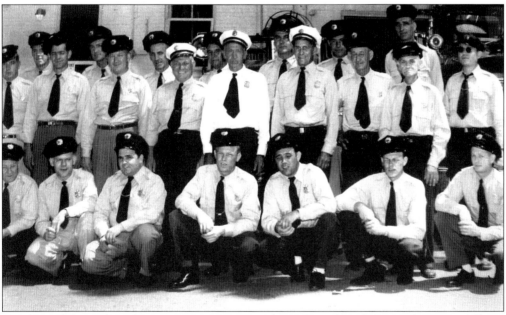

Members of the early volunteer Fire Department, shown here from left to right, are as follows: (front row) Al Fisher, Joe Garret, Frank Seisner, Mel Laramie, Walt Meyer, Charles Castello, Bill Meyer, and Al Schoettler; (center row) Louis Behlmann, Ray Laramie, Walt Wagner, Charles Garrett, Chief Harry Nemich, Cyril Niehoff, Bill Koester, and Henry Rickelman; (back row) Herb Nemich, Frank Korte, Gerald Gettemeyer, Lawrence Lohe, Robert Tebeau, Carl Peters, Oscar Laramie, Art Behlmann, and Edward Wagner. (Photo courtesy of the City of Florissant.)

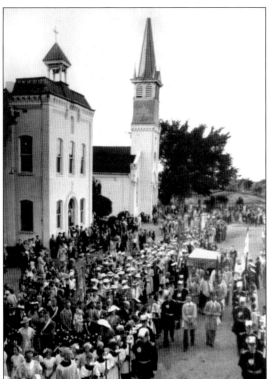

One of the early celebrations of the City of Florissant was the Corpus Christi Procession. This early 19th century Florissant tradition was revived for a time in the 1930s. Here the procession is filing past the Old St. Ferdinand Shrine in Old Town Florissant. (Photo courtesy of the Mercantile Library.)

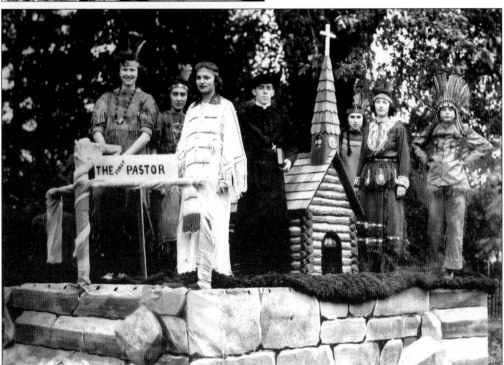

These youngsters are commemorating St. Ferdinand's first pastor, Father Didier, during a 1940s Corpus Christi parade. (Photo courtesy of the Mercantile Library.)

Florissant's own Rita Meyer Moellering, a graduate of Sacred Heart Parish School, became a pioneer in the mid 1940s when she joined the Peoria Red Wings of the All-American Girls' Professional Baseball League. She played shortstop from 1946 to 1949. Moellering was scouted while playing softball for the old Weik Funeral Home in Florissant. A teammate nicknamed her "Slats" because her style of play at shortstop was similar to the Cardinals great, Marty "Slats" Marion. (Photo courtesy of Laura Moellering.)

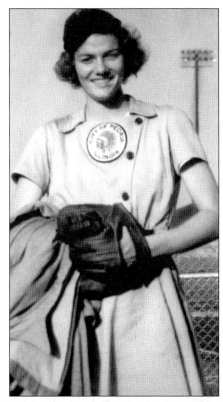

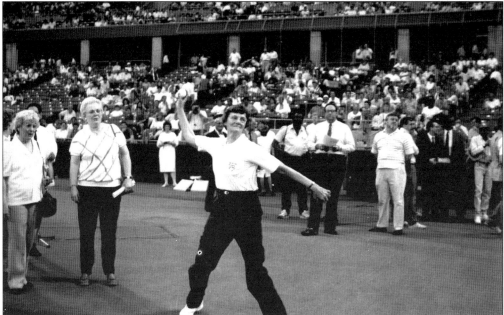

Rita Meyer Mollering is shown throwing a ball before a game at Bush Stadium after the release of the film *A League of Their Own* in which she played an extra. The film, directed by Penny Marshall and starring Tom Hanks and Madonna, was about a women's baseball league during World War II. (Photo courtesy of Laura Moellering.)

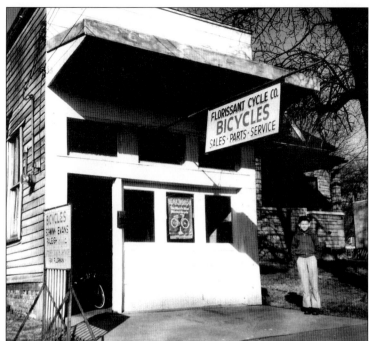

The Florissant Cycle Company, operated by Raymond J. Florman, was one of the favorite shops for the young and old. His son, Raymond J. Florman, is shown here outside the bicycle shop at 225 rue St. Francois in 1959. It is believed by many that this building may be the oldest commercial building in the City of Florissant. (Photo courtesy of Marilyn Geiger.)

Henry Fischer and his wife opened Fischer's Department Store at 601 Jefferson in 1934. At that time the store specialized in the sale and repair of shoes and harnesses. However, as the community began to grow, so did its needs. Fischer expanded his store to include dry goods. At that time most of the men wore blue shirts, overalls, and work shoes, which could be purchased at Fischer's for about $2.50. Top-grade muslin, used to make the family clothing, sold for 12¢ per yard. As the Fischer's began to prosper, Henry turned the business over to his sons, Al and Jim. (Photo courtesy of Don Fischer.)

Three
YEARS OF GROWTH

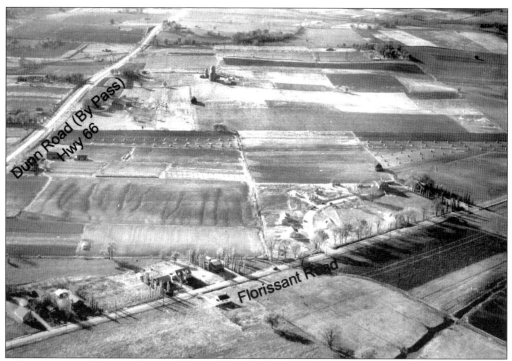

When World War II ended, Americans needed homes and Florissant was the nucleus of a city. It had water, the beginnings of a sewer system, fire protection, and acres and acres of beautiful land around it. The war had brought new industrial plants to the vicinity of Florissant and also a need for housing. The town met the challenge for the housing boom through annexations and construction, and the population increased from 3,737 in 1950 to 38,166 by 1960. Along with this sudden growth came a host of schools, churches, and businesses. (Photo courtesy of John Kohen.)

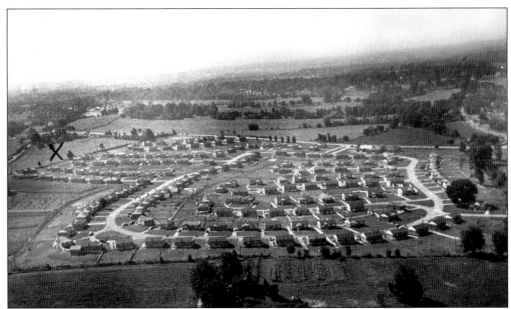

This photo was taken in 1949 during the early construction of the Duchesne subdivision, which is one of the many subdivisions that later developed in Florissant to provide homes for new families after the war. Much of the area around the subdivision was still farmland. The "X" on the left-hand side of the picture is the location of the present Our Lady of Fatima Catholic Church. (Photo courtesy of Our Lady of Fatima Church.)

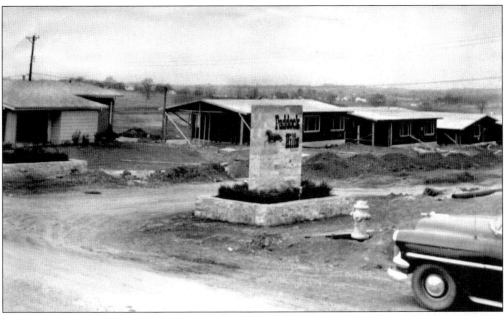

Between 1947 and the mid-1970s, about 18,000 homes were built in the city and the population attained a peak of 65,908. Developers like Alfred Mayers, builder of the Paddock Hills subdivision in 1956, left their mark on the community by their choice of street names. Mayer chose equestrian terms for this subdivision, such as Mustang Court, Horseshoe Drive, and Thoroughbred Lane. (Photo courtesy of the Mercantile Library.)

The sudden rapid growth in the little town of Florissant demanded that another parish be added to the community. Sacred Heart and St. Ferdinand were taking care of the needs in historic Old Town. Real estate developer Joseph H. Vatterott bought and donated approximately six and one-half acres of land at Highway 66 (now Dunn Road) and Old Florissant Road (now Washington Street) for the construction of a church. This small frame church was erected facing the highway, at what is now Johnny Londoff Chevrolet. Thus Our Lady of Fatima was born. From this small beginning between 1955 and 1959, five new parishes evolved: North American Martyrs, St. Dismas, Good Shepherd, St. Bartholomew, and St. Thomas the Apostle. (Photo courtesy of Our Lady of Fatima.)

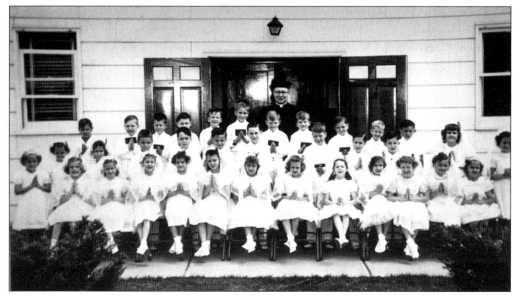

A first communion class from the early 1950s poses for a photo in front of the original white frame building that housed Our Lady of Fatima parish. (Photo courtesy of Our Lady of Fatima.)

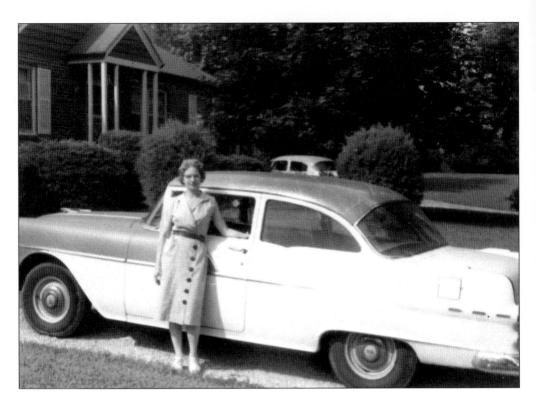

By 1960, Florissant described itself as a city comprised of mostly prosperous young families, with a median age of 21.3 years compared to 29.5 years for the rest of the nation. And with an average family income of $8,626 per year compared to $6,661 for the rest of the nation. For many, Florissant was an ideal place to live and realize the American dream. (Photo courtesy of Kathi Asikainen.)

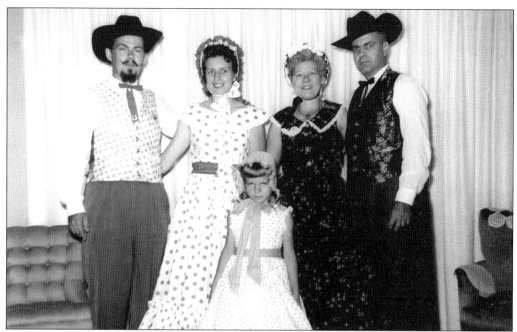

In 1957, when the city celebrated the hundredth anniversary of its founding, the whole town got involved. The men grew beards and the women dressed in period clothes. To celebrate this special event there were parades, theatrical productions, square dancing, and a souvenir booklet that told the Florissant story. (Photo courtesy of Kathi Asikainen.)

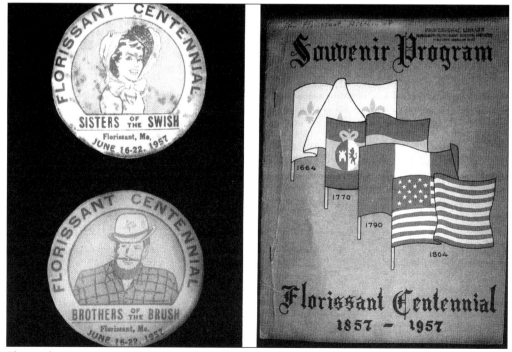

Shown here are some of the souvenirs from the Florissant Centennial. (Courtesy of Kathi Asikainen and the Ferguson–Florissant School District.)

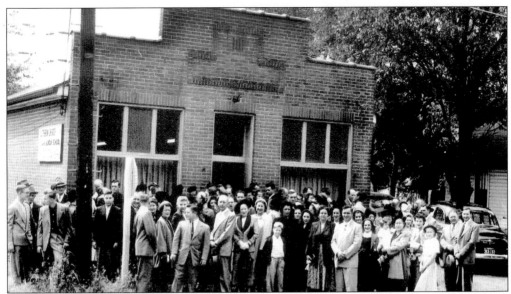

On August 26, 1951, about 40 people attended a meeting of prospective Atonement Lutheran members at the home of Mr. and Mrs. J.A. Jutzi, at 1545 E. Duchesne Drive. They formally organized, chose the name Atonement for their congregation, which described the central tenet of their faith. While shaping their vision, the congregation rented the former shop of E.L. Ballard Plumbing Co., on the south west corner of St. Francois and St. Ferdinand streets. Members are pictured outside that building on September 30, 1951. (Photo courtesy of Atonement Lutheran Church.)

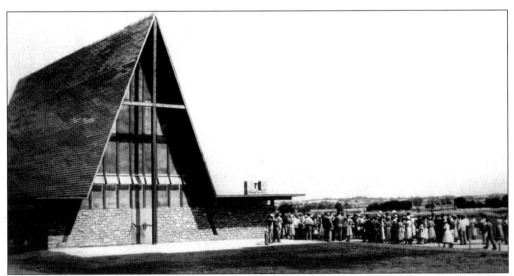

As soon as the congregation moved into its rented facility, on St. Francois and St. Ferdinand streets, it retained Harris Armstrong, an outstanding St. Louis architect with a national reputation, to design and prepare plans for a church building. One year and seven months later the congregation moved into its new facility. Because of its unique design the church received national attention. It was featured in the magazines *Contemporary Architecture* and *Architectural Forum*. It also received a great deal of coverage in the *St. Louis Post Dispatch* and *Reader's Digest*. (Photo courtesy of Atonement Lutheran Church.)

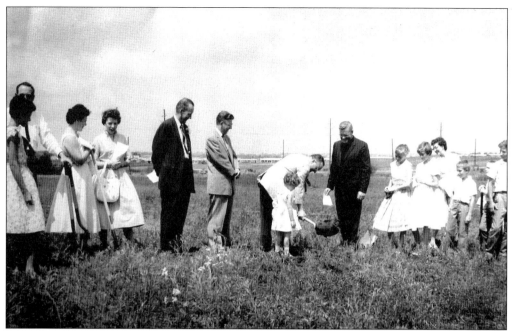

After being organized by the St. Louis Presbytery, the 110 charter members of John Knox Presbyterian Church began meeting at Robinwood Elementary School on Derhake Road on January 1, 1959. Six months later, in July 1959, groundbreaking on the 12-acre tract of land at 13200 Halls Ferry Road was followed by construction of the original Sanctuary, the present Celtic Hall, and the preschool and nursery wing. As can be seen, Halls Ferry Road was still mostly undeveloped. (Photo courtesy of John Knox Presbyterian Church.)

Today John Knox is very active in the community and is the meeting facility for Boy Scout Troop #772, Girl Scout Troop #4239, WHM Services, and NCCU (North County Churches United for Racial Justice), which John Knox was instrumental in starting. The following groups rent the church facilities on a regular basis: Missouri Promenades, karate classes, and two aerobic classes. (Photo by John A. Wright.)

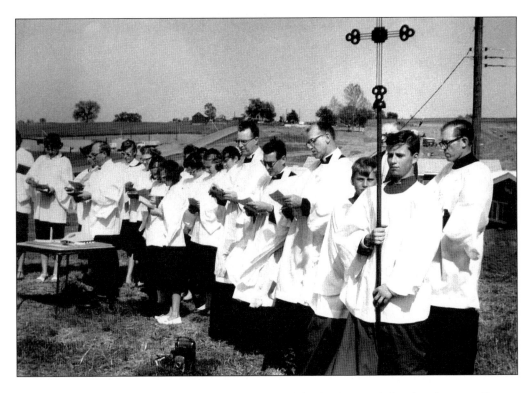

When St. Barnabas was constructed in 1955, most of the land around the church was still open field. Members of the church are seen in the top picture at the groundbreaking. Christ the King Evangelical Lutheran Church, Church of the Master Evangelical and Reformed, and Assembly of God Church were among others who broke ground for construction during the 1950s to meet the religious needs of the ever growing Florissant population. (Photo courtesy of St. Barnabas Church.)

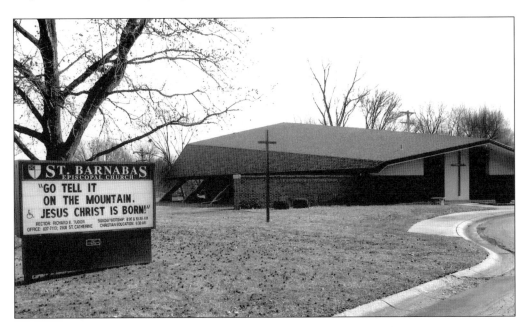

In February, 1938, the Baptists of the community felt a need to withdraw from the Union Church, which had been established for Methodists, Presbyterians, and Baptists at 646 rue St. Francois. They banned together and began meeting in the old post office on the southeast corner of St. Francois and Jefferson Streets. Two months later, the First Baptist Church of Florissant was born. The church continued to grow and they purchased their present site, constructing this church building in 1944 and parsonage in 1950. In 1946, the church was renamed Florissant Valley Baptist Church (Photo courtesy of Florissant Valley Baptist Church.)

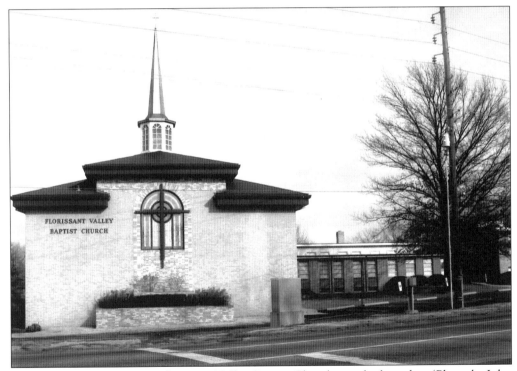

Pictured here is the present Florissant Valley Baptist Church as it looks today. (Photo by John A. Wright.)

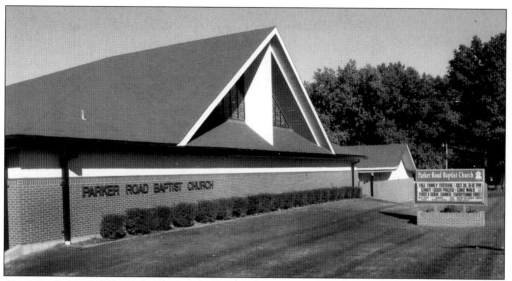

On March 9, 1955, the Florissant Valley Baptist Church voted to establish a Mission Committee for the purpose of seeking out suitable property for a mission. On March 1, 1956, a contract was signed for the purchase of two and one-half acres of property at 2675 Parker Road, for $11,500. On April 20 the following year, nine adults and fifteen children set out from Florissant Valley Baptist Church, gathered in the gymnasium of Parker Road Elementary School to start the work of Parker Road Mission, now known as Parker Road Baptist Church. September 19 of the following year the cornerstone was laid, containing the names of the charter members and the history of the church. (Photo by John A. Wright.)

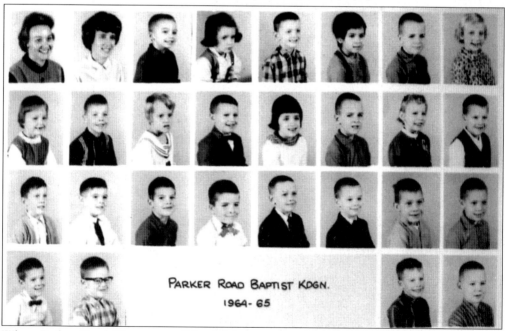

When Parker Road Elementary School became overcrowded Parker Road Baptist Church became the site of its kindergarten. Pictured here is the 1964–1965 class. (Photo courtesy of Parker Road Baptist Church.)

50

In 1955 the Parish of St. Ferdinand's ceased using the 1821 brick church, now St. Ferdinand's Shrine, and moved to this new church at 1765 Charbonier Road. The St. Ferdinand parish operates an elementary school that serves students in kindergarten through eighth grade. (Photo courtesy of the Mercantile Library.)

St. Mark's United Methodist Church was conceived in September 1954, when 29 worshippers gathered in the home of Mr. and Mrs. Louis Gunther and created a part of an extension of the mission of the Ferguson Methodist Church. Groundbreaking for the first St. Mark's building was on July 8, 1955 at 360 Graham Road, across the street from the present sanctuary. In February 1960, seven and one-half acres were purchase at 315 Graham Road and groundbreaking was held on March 10, 1963. The church was an early supporter of civil rights. Because of its support of a low- and middle-income housing development in the Black Jack area, it lost some of its members. Black Jack incorporated, fought the development, and wrote laws against allowing African Americans to live in the city. (Photo by John A. Wright.)

To meet the growing population of the Florissant community, Hazelwood School District constructed six schools: Jana, Lusher, McCurdy, Lawson, Walker, and Hazelwood Middle. The schools were placed under the leadership of superintendents Clifford R. Kirby (left) from 1953 to 1967, and C.O. McDonald (right) from 1967 to 1974. (Photos courtesy of the Hazelwood School District.)

This an aerial view of Jana Elementary in 1970, under construction at 405 Jana Drive. It can be easily seen that the area around the school is still underdeveloped. (Photo courtesy of Mercantile Library.)

Under the leadership of Virgil McCluer (left) from 1930 to 1967 and Warren Brown (right) from 1967 to 1983, the Ferguson–Florissant School District constructed the following schools to meet the needs of the southern end of the city: McCluer High School; Cross Keys and Florissant Junior High Schools; and Graham, DeSmet, Combs, Wedgwood, Parker Road, Halls Ferry, Duchesne, Robinwood, and Mark Twain Elementary Schools. (Photos courtesy of the Ferguson–Florissant School District.)

This photograph was taken during the construction of Florissant Junior High School. The school was closed in the 1980s and is presently the administration center for the Ferguson–Florissant School District. It also houses the District's Staff Development Center, Gifted Center, Early Childhood Program, and Community School. (Photo courtesy of the Mercantile Library.)

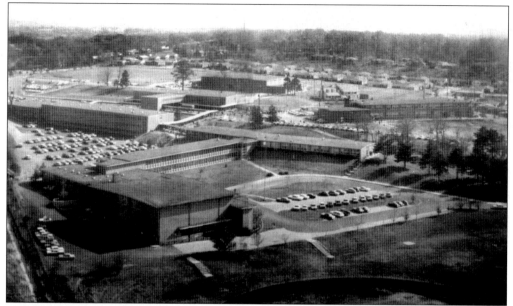

McCluer began as a junior high school in the M1 building in 1951. It continued to grow as the student population increased until it reached the point in the 1960s where school had to be held in double sessions, with some students coming early in the morning and others leaving late in the evening. (Photo courtesy of the Ferguson–Florissant School District.)

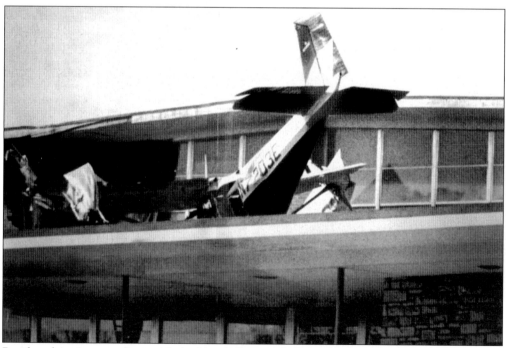

Besides the overcrowding and double shifts at McCluer High School the students and community will never forget February 19, 1968, when a plane flew into the building while school was in session. Thankfully, no one was injured. (Photo by Peter Davidson courtesy of McCluer High School.)

In order to relieve the student overcrowding at McCluer High School, the Ferguson–Florissant School District submitted a bond issue to the voters for the construction of a second high school, McCluer North. Because of the district's limited bonding capacity, brought on by continuous school construction, it had to go to the voters three times as money became available. The voters knew in the beginning they had to commit themselves to all three bond elections or the school would not be completed. (Photo by John A. Wright.)

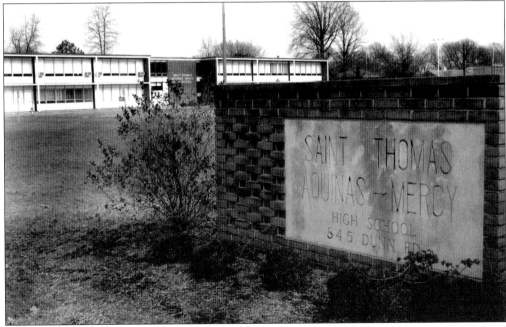

To meet the needs of Catholic students, the now closed St. Thomas Aquinas–Mercy High School was constructed. It was one of the first high schools in the Midwest to be constructed on a campus plan. The school began in 1954 in the old Sacred Heart School building in Old Town Florissant. During its early history it had several names. It was first known as St. Pius X, then Duchesne, then St. Joseph Schools. In 1956 it was renamed for the patron of Catholic schools, St. Thomas Aquinas. Mercy was added to the named when it merged with Mercy High School in 1985. The school had over 18,000 graduates in its combined history. (Photo by John A. Wright.)

55

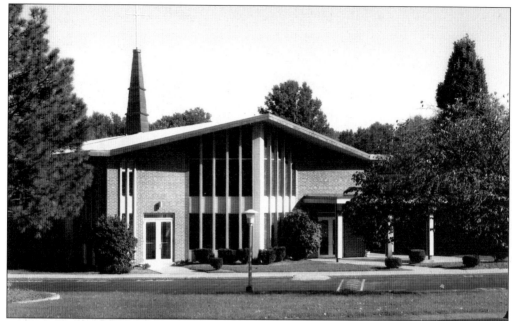

St. Thomas the Apostle Parish was formed on May 9, 1960 on land donated to the St. Ferdinand Parish. When Cardinal Ritter announced the creation of St. Thomas and St. Sabina Parishes it made Florissant the forth city in the state in the number of Catholic parishes at the time, behind only to St. Louis, Kansas City, and St. Joseph. The first Mass was held in the rectory chapel, and later in St. Thomas Aquinas High School until a new church and school were constructed. (Photo by John A. Wright.)

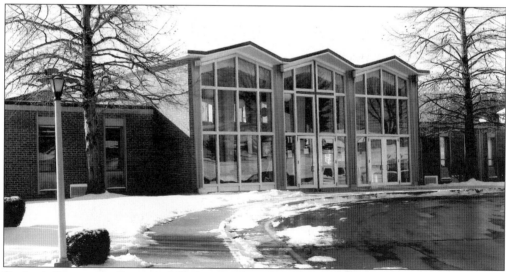

St. Louis Preparatory Seminary-North opened in 1965 on grounds adjacent to St. Thomas the Apostle Parish. The seminary facilities were sold in 1987 to the St. Thomas Parish, who sold their church and school to a developer for the creation of housing for the elderly. St. Thomas had used the chapel at the seminary for over twenty years for church services. St. Thomas now operates an elementary school on the property, which is accredited by the National Federation of Non-Public School State Accrediting Association, along with its parish church. (Photo by John A. Wright.)

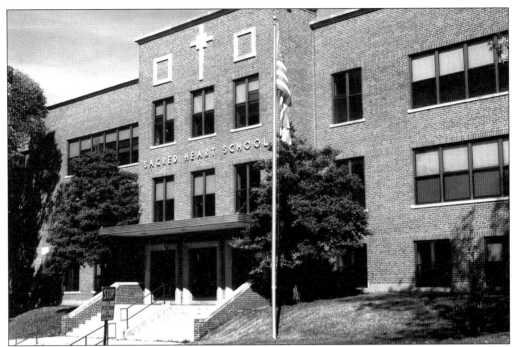

In order to meet the growing needs of its parish, Sacred Heart began construction on a new and larger school in 1951. The cornerstone was laid by Father Wilfred Charleville, Pastor, on March 23, 1942. Today the school has an enrollment of 350 students in the first through eighth grades. (Photo by John A. Wright.)

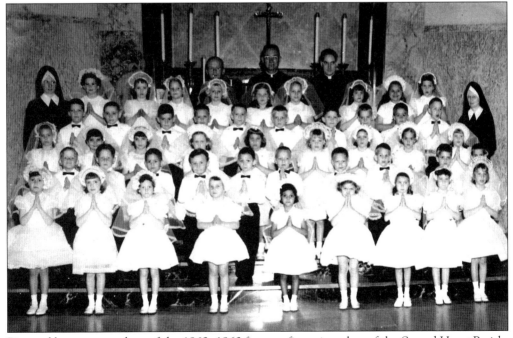

Pictured here are members of the 1962–1963 first confirmation class of the Sacred Heart Parish. (Photo courtesy of Maureen Pfeifer.)

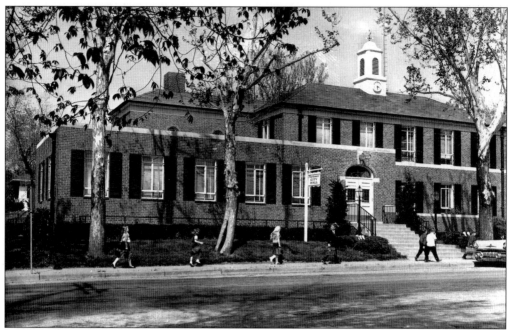

In 1955, the City of Florissant dedicated its second city hall, pictured here, and turned over the first city hall for a city library. The Florissant Public Library began in rooms above the Citizen's Bank of Florissant, at 699 St. Francois, with a donation collection of 1,005 books. The City of Florissant took over the operation of the library in 1942. (Photo courtesy of the City of Florissant.)

By 1960, the police force had grown to 34 men and nine vehicles, which traveled over 368,000 miles. During the peak crime season the city added two officers dressed in civilian clothes to the special investigative unit. (Photo courtesy of the City of Florissant Police Department.)

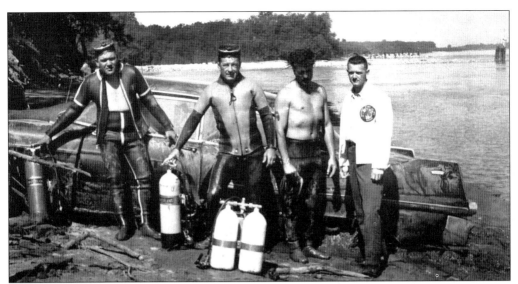

The City of Florissant had one of the few commissioned police officers trained in St. Louis County to don scuba gear and recover stolen autos, safes, drown victims, and other contraband from rivers and lakes. (Photo courtesy of the City of Florissant Police Department.)

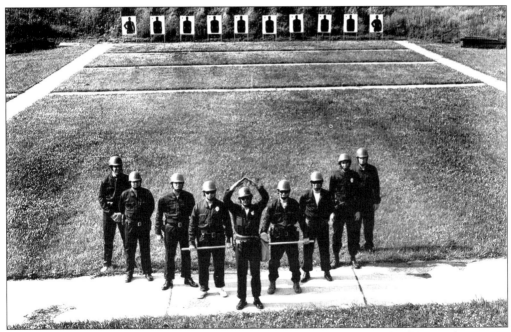

As the community began to grow there became a need for a new type of policing. The routine duties of enforcing a weed-cutting ordinance, jailing a drunk, burying a dead dog or cat, or citing people who let cattle or horses roam the streets were becoming duties of the past. Authorized equipment such as hammers for breaking rocks, balls and chains, and locks for prisoners were also no longer needed or used. During the 1960s the police department inaugurated an in-service training school to keep the department operating at high efficiency. These men are at the city's pistol practice range, modeled after the Weldon Springs FBI range. (Photo courtesy of the City of Florissant Police Department.)

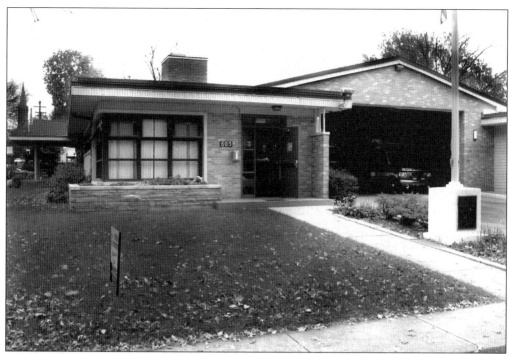

On November 11, 1956, the Florissant Valley Fire Protection District dedicated its new fire station at Jefferson and St. Catherine Streets. Two paid firemen, Carl J. Peters and Albert J. Schoettler, assumed their duties in January 1957. The volunteer officers at that time were Harry Nemnich, chief; Cyril A. Niehoff, assistant chief; Charles S. Garrett, captain-treasurer; Art Behlmann, secretary; and William T. Meyer and Edward Wagner, directors. Two and one-half years later, when the Washington Street No. 2 House went into operation, 14 full-time men were employed by the district. (Photo by John A. Wright.)

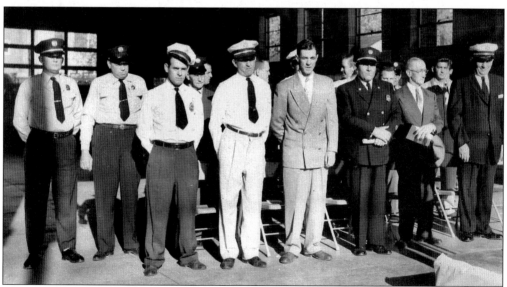

Pictured here are some of the city dignitaries present at the dedication of the new fire station at 605 St. Catherine Street. (Photo courtesy of the Florissant Valley Fire Protection District.)

60

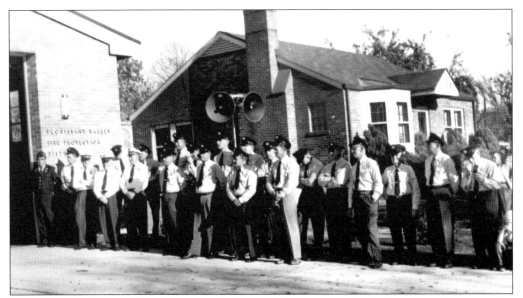

Some of the volunteer fire men are shown here as they observe the dedication of their new fire station. (Photo courtesy of the Florissant Valley Fire Protection District.)

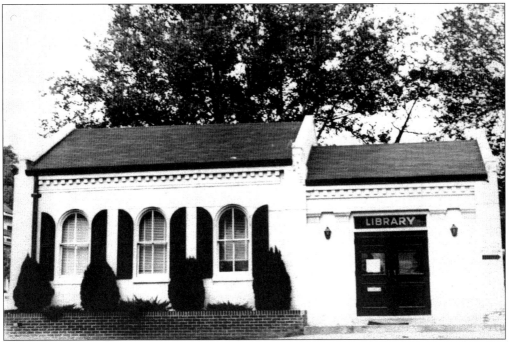

After the dedication of the new city hall, the old city hall became the new home of the city library. The Florissant Valley Library Association started out in 1940, in rooms above the Florissant Bank, which later became the library. When the state library tax was levied, Florissant voted to maintain its own library and levy its own tax rather than become a part of the state library. By 1961, the library's circulation reached about 333,000, an increase of 10,000 from the year before. In 1957, the entire circulation was 34,000, and in 1959 it was 130,290. (Photo courtesy of the City of Florissant.)

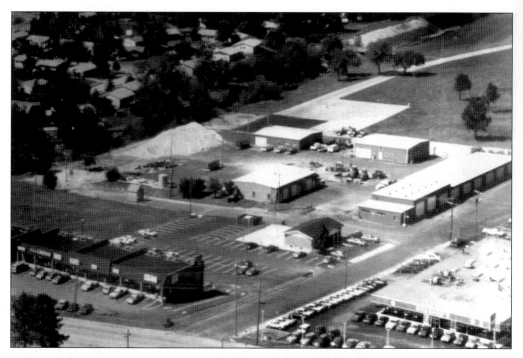

By 1961, the city was maintaining 112.01 miles of streets from its garage. The Department of Public Works counted inspecting new street construction, reflectorizing street and traffic signs, street and sidewalk survey, systematizing rapid snow removal and salt spreading, looking after foot bridges on Parker Road and Highway 140 for school children's safety, and street repair among their many duties. (Photo courtesy of the City of Florissant.)

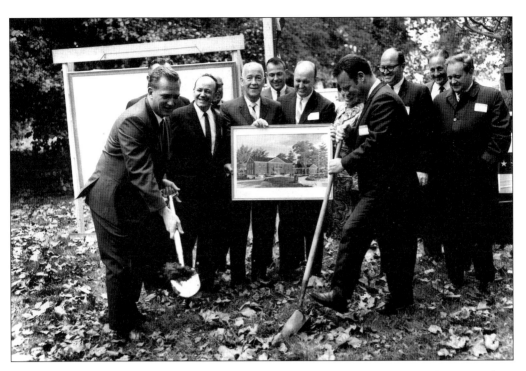

In 1970, the present Florissant City Hall was dedicated at 955 rue St. Francois. Some members of the community and state officials are shown above at the groundbreaking. This new facility provided the city with the needed space to meet the needs of its growing population. (Photo courtesy of the City of Florissant.)

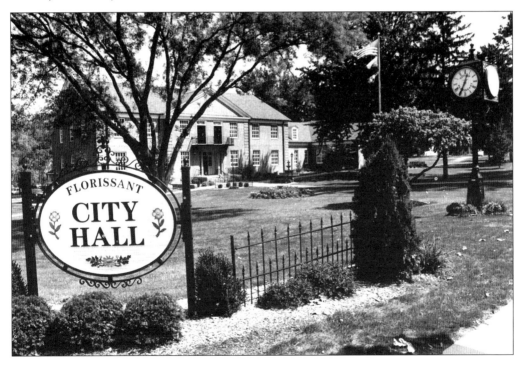

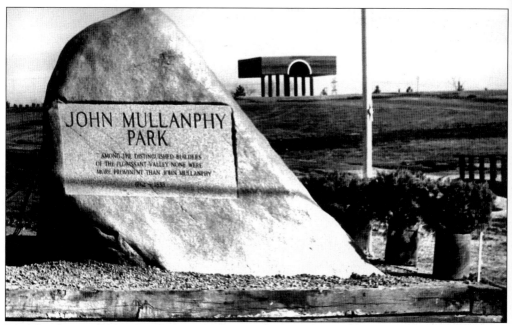

In 1960, the city had only 35 acres of park area and felt it was 65 acres short of the minimum required for a city of its size, based on the standards of the National Recreation Association. To reach its goal, the city began to acquire land before it was no longer available. The 9 and one-half acre John Mullanphy Park at Mullanphy and Nigh Drive was one of those dedicated during the 1960s. (Photo courtesy of the Mercantile Library.)

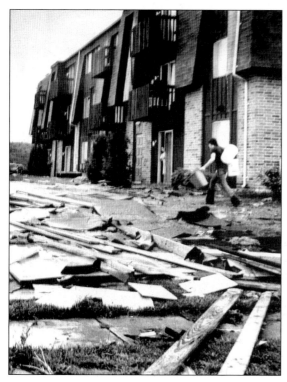

One of the setbacks of the 1970s was the 1972 tornado, which traveled through parts of the community destroying thousands of dollars in property. (Photo courtesy of the Mercantile Library.)

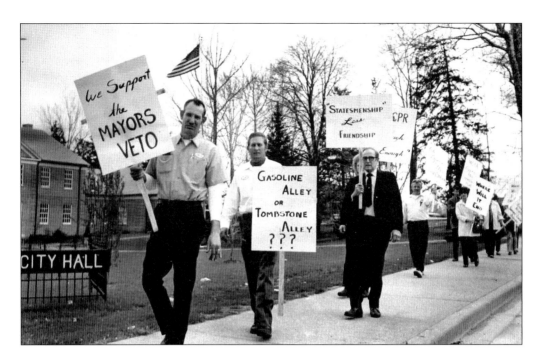

The years of growth brought many challenges to the city, some in the form of peaceful protest. In the top photo citizens are protesting a decision on the growth of service stations along Lindbergh Boulevard and at the bottom parents of parochial school children are protesting to get free transportation for their children. (Photo courtesy of the Mercantile Library.)

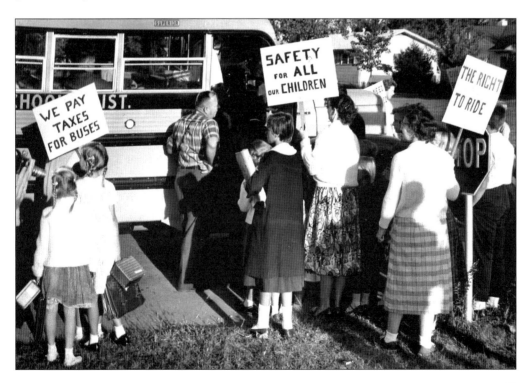

One of the major challenges for the community came in 1975, when the courts ordered the Ferguson–Florissant School District to be a part of a three-district merger for the desegregation of the Kinloch School District. This was the first three-district merger in the United States. The court made Ferguson–Florissant a part of the suit because it felt the district could have assisted in the needs of the Kinloch School District when Ferguson merged with the Florissant School District in 1950. The merger placed approximately 1,300 Kinloch students into the Florissant schools without incident. Kinloch was a part of the Ferguson District until 1902, and Berkeley was a part of the Kinloch District until 1939, when it broke away for racial reasons, taking away Kinloch's resources. (Document courtesy of John A. Wright.)

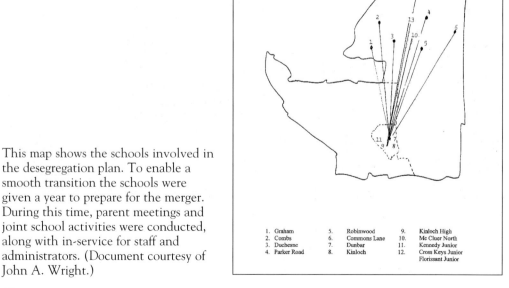

Location of the Elementary and Secondary Schools Involved in the
1975 Court Ordered Desegregation Plan

1.	Graham	5.	Robinwood	9.	Kinloch High
2.	Combs	6.	Commons Lane	10.	Mc Cluer North
3.	Duchesne	7.	Dunbar	11.	Kennedy Junior
4.	Parker Road	8.	Kinloch	12.	Cross Keys Junior
					Florissant Junior

This map shows the schools involved in the desegregation plan. To enable a smooth transition the schools were given a year to prepare for the merger. During this time, parent meetings and joint school activities were conducted, along with in-service for staff and administrators. (Document courtesy of John A. Wright.)

In 1982, the city dedicated its new police headquarters at 1700 North Lindbergh. It is shown here in the midst of construction. (Photo courtesy of the Mercantile Library.)

In spite of all the incidents and events of the 1960s and 1970s, Florissant was found to be the second safest city in America, according to United States Department of Justice Urban Crime Report for cities with populations between 50,000 and 100,000. Receiving an award for the city, from right to left, are: Col. Robert Lowery Sr., Mayor James Egan, Special Agent Kenneth Cloud, and Norman Williams. (Photo courtesy of the Mercantile Library.)

With a reputation for being a fine city, Florissant became the place to be for a number of businesses, along with residents. In 1966, Yacovelli moved its restaurant to 427 Dunn Road. It is one of the oldest names in the St. Louis restaurant business, founded in 1919. In 1953, it originated the idea of a salad bar, which revolutionized the restaurant industry. It began a trend that is now used across the country. (Photo courtesy of Jan Yacovelli.)

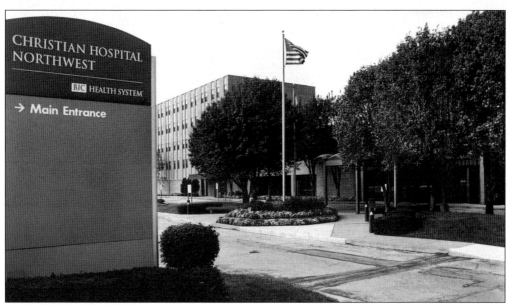

In 1968, Christian Hospital Northwest, at Graham Road and Highway 270, offered a 260-bed capacity and emergency service on a 24-hour basis. Today, out of 111 hospitals in the state, Christian Hospital ranks in the top 4 for overall quality of care. In crucial areas like stroke, pneumonia, and heart attack treatment, Christian Hospital is considered to provide outstanding care to the metropolitan area. (Photo by John A. Wright.)

Four

PARKS, FESTIVALS, AND CELEBRATIONS

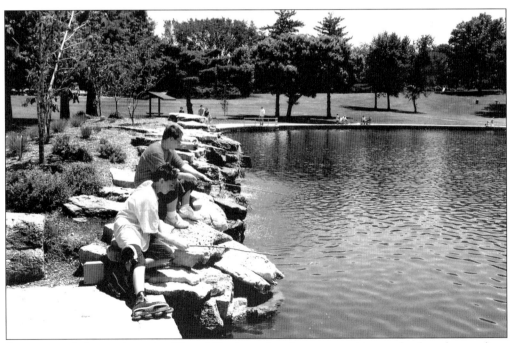

Since its early beginnings, the City of Florissant has been an exciting and a fun place to live. The city, through its Parks and Recreation Department, offers residents 20 parks comprising almost 400 acres, a variety of recreation facilities, including two community centers, an aquatic center, an 18-hole public golf course, a covered ice rink, skateboard park, and many recreation programs and services. The city is alive with activities throughout the year with such events as the Valley of the Flowers, Fall and Thai Festivals, Christmas Walk, and Corpus Christi procession, to name a few. (Photo courtesy of the City of Florissant.)

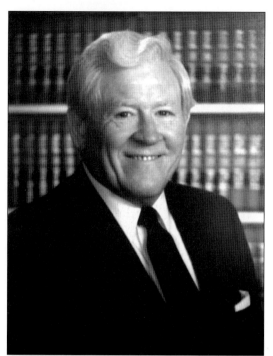

In 1963, James J. Eagan became the city's first mayor elected under its new charter and served for thirty-seven years, dying in office on November 2, 2000. As the first mayor under the new charter it was his responsibility to reorganize city government. Under his administration, a new city hall and the community center and civic center below, with a six hundred-seat theater, were constructed. He served as president of the Missouri Municipal League and chaired the Missouri Intergovernmental Risk Management Association. (Photo courtesy of the City of Florissant.)

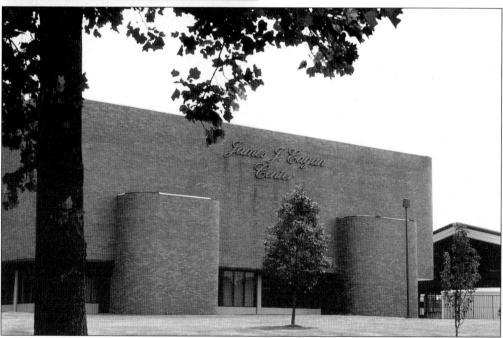

After Mayor Eagan's death, the Florissant Civic Center, located at Parker Road and Waterford Drive, was renamed the Florissant James J. Eagan Center to honor Eagan's service to the community. The center includes an indoor swimming pool, gymnasium with a multipurpose room, capabilities for large group functions, covered ice rink, youth lounge, meeting rooms, an arts and craft room, a full catering kitchen, an exercise room, and the FCC Theatre and Art Gallery. (Photo courtesy of the City of Florissant.)

Residents have at their disposal an exercise room at the Eagan Center, which is equipped with weight lifting and cardiovascular equipment of various types. The center also has a gymnasium that can be divided into two regulation basketball courts with a divider, or as a full-size regulation court with bleachers seating 800 spectators. (Photo courtesy of the City of Florissant.)

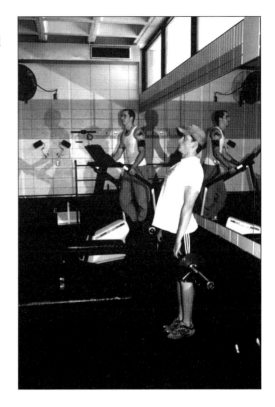

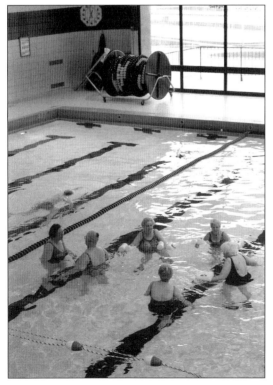

These senior citizens are enjoying a morning swim in the six-lane pool at the Eagan Center. The pool area has a seating gallery for 200 spectators and an indoor spa for recreational and therapeutic purposes. (Photo by John A. Wright.)

The John F. Kennedy Community Center, located at 315 Howdershell in Koch Park, provides residents a gymnasium and multipurpose room, youth lounge, exercise room, meeting room, and arts and crafts room. (Photo courtesy of the City of Florissant.)

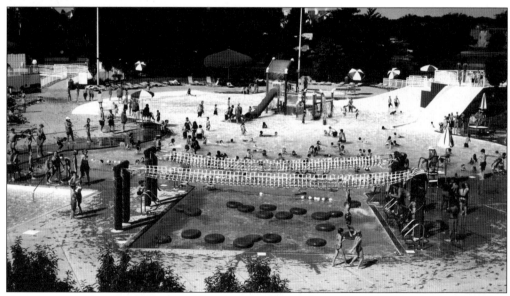

A major attraction for residents is The Aquatic Center located at 305 Howdershell Road in Koch Park which opened in August 1995. It features a variety of colorful attractions for children and adults such as an 880-foot lazy river with inner tubes for floating which encircles the Main Activity Pool, a lap swim area, a water play structure, zero depth entry, lily pad walk, infant and teen Otter Slide, concession with funbrellas for shade and the "Whompuscat" slide. The park is named for former Mayor Henry F. Koch, 1960–1963, the City's first full time mayor. (Photo courtesy of the City of Florissant.)

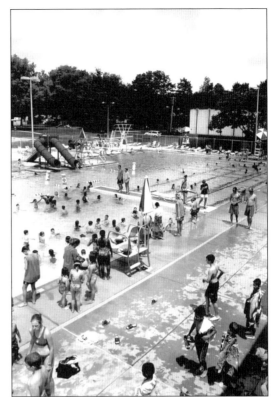

Bangert Park at 275 South New Florissant Road, the city's oldest park offers residents a newly renovated competition style outdoor swimming pool with bathhouse, covered pavilions for picnics, a lighted roller hockey area and an interesting Sherman Tank. During the summer programs the park department provides transportation to and from the park for children. (Photos courtesy of the City of Florissant.)

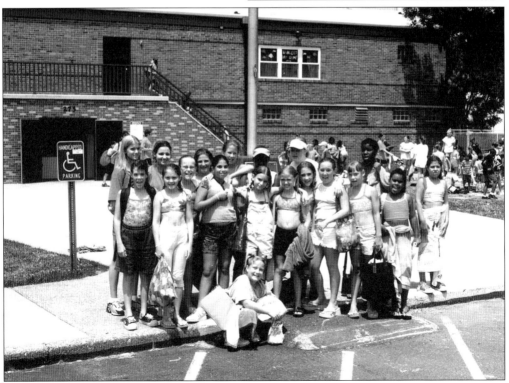

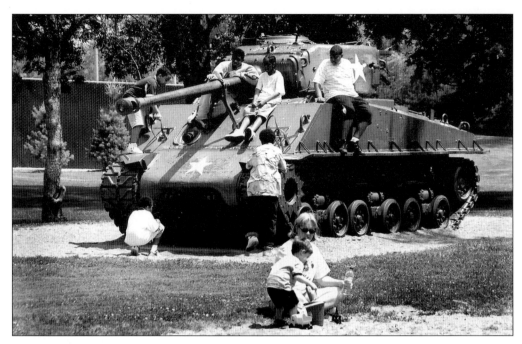

Kids love to play on the Sherman Tank in Banert Park. Other excellent playground facilities can be found through out the City of Florissant, like the one pictured below, at the following parks: Blackfoot at Canisius and Gonzaga streets, Duchesne at Brower Court off Washington Street to St. Charles Street, Dunegant at Derhake and Pohlman Roads, St. Ferdinand at St. Ferdinand and north of Highway 67, Marion off Graham Road, and Florissant at Parker and Waterford Roads. (Photos courtesy of the City of Florissant.)

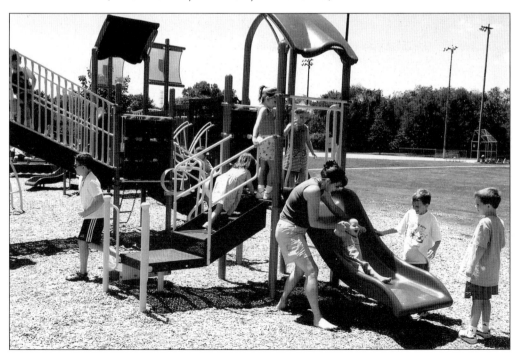

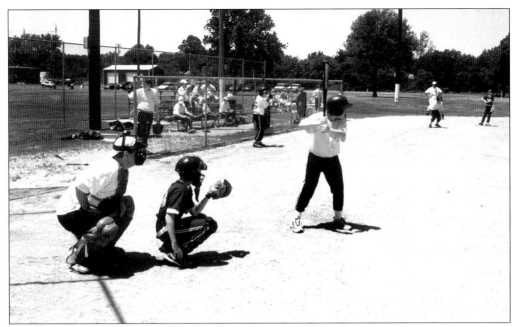

The city offers baseball, softball, soccer fields, handball courts, and lighted multi-purpose courts and tennis courts throughout the community. The Ozzie Smith Academy for soccer and basketball is a favorite for youngsters. (Photo courtesy of the City of Florissant.)

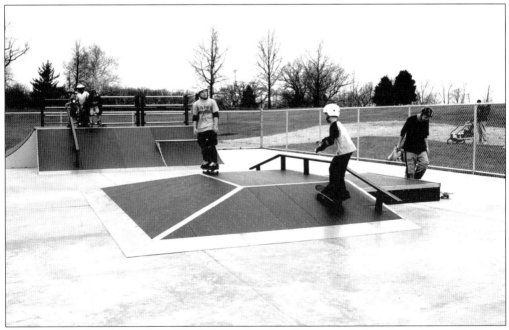

The Donald L. Bond Skateboard Park, located within Dunegant Park at Derhake and Pohlman Roads, was the first municipal skate park in the St. Louis Metropolitan area, and has skaters coming from as far as Columbia, Missouri. The park is named for Captain Francois Dunegant, who established the first civil government in Florissant in 1786 and served as the city's first military and civil commandant. (Photo courtesy of the City of Florissant.)

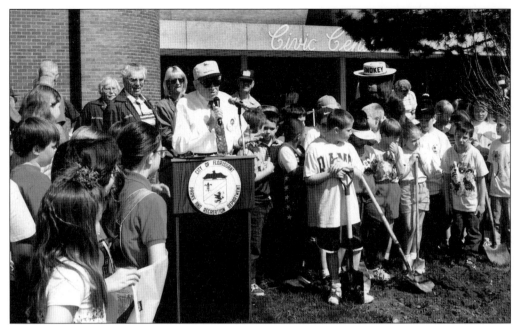

Arbor Day celebration is a time set aside each year for the residents of the city to plant trees to help maintain the beauty of the community. These youngsters are gathered with former Mayor James Eagan and Smokey the Bear outside the Civic Center to celebrate the occasion with the planting of trees. (Photo courtesy of the City of Florissant.)

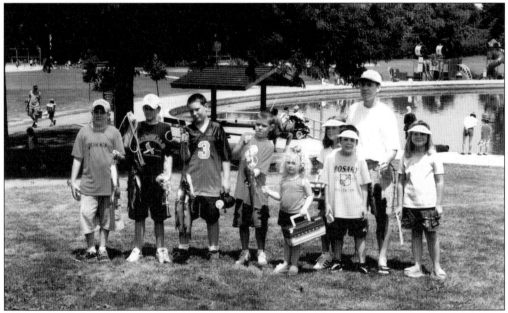

These youngsters are proud participants in the city's annual fishing tournament, sponsored by the Parks and Recreation Department and the Youth Advisory Commission. The tournament has attracted hundreds of youngsters since it began seventeen years ago. St. Ferdinand Lake, where the tournament is held, is periodically stocked and is available for fishing from 8 a.m. to 11 p.m. daily. (Photo courtesy of the City of Florissant.)

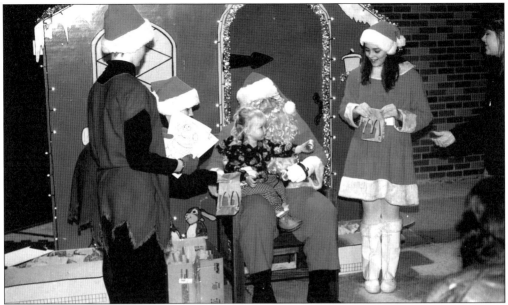

The city's Parks and Recreation Department provides a variety of activities for young children year round, such as snack with Santa; Youth Evening Programs, where young people can learn to make Christmas presents, Halloween, and Thanksgiving decorations; and candle making. The department also offers a junior dance, a cartooning made easy workshop, petite dance, karate, gymnastics, and a host of activities to numerous too mention. (Photo courtesy of the City of Florissant.)

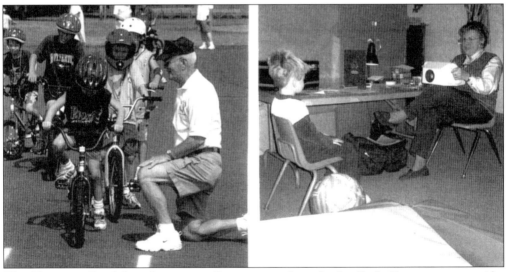

The Florissant Disability Awareness Commission through the Park Department provides helmet fitting, bicycle safety courses, and a car seat safety check at different times throughout the year for city residents. Digital photos and fingerprints on a floppy disk are available through the Shawn Hornbeck Foundation at the James J. Eagan Center daily from 4 p.m. to 7 p.m. The Florissant Valley Lions Club, working with the city, provides free Amblyopia screening. Since the program began in 1975, over 38,047 children have been screened in the State of Missouri. (Left photo courtesy of the City of Florissant and right photo by John A. Wright.)

The City of Florissant operates an 18–hole championship golf club, comprising approximately 135 acres at 50 Country Club Lane, one-quarter mile south of North Highway 67, off Old Halls Ferry Road. The golf course measures 6,590 yards from the championship tees. During the golf season, Old Fleurissant Golf Club has many programs available to golfers which include ladies leagues, couples leagues, junior camps and leagues, and individual and group lessons. (Photo by John A. Wright.)

The Old Fleurissant Golf Club house, which is opened to players before and after a round of golf, has banquet facilities and offers a variety of menus for breakfast, lunch, and dinner. It also has a variety of in-stock tournament merchandise for sale, and merchandise that can be created, with enough notice, featuring a tournament logo on balls, shirts, towels, hats, etc. (Photo courtesy of the City of Florissant.)

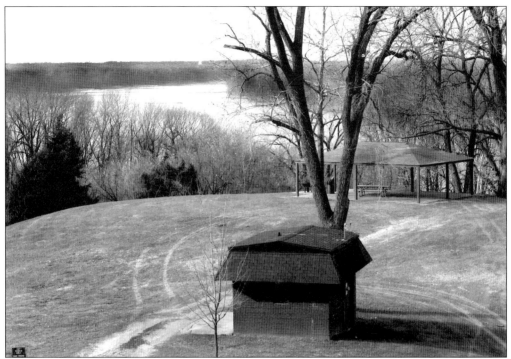

From sun-up to sun-down, the 90-acre Sunset Park located on the Missouri River bluffs offers residents scenic views of the river from a number of locations, especially from the pavilion pictured here. The park has trails leading down to the banks of the river. Future plans for the area include a marina with a beautiful recreation area for children of all ages. (Photo by John A. Wright.)

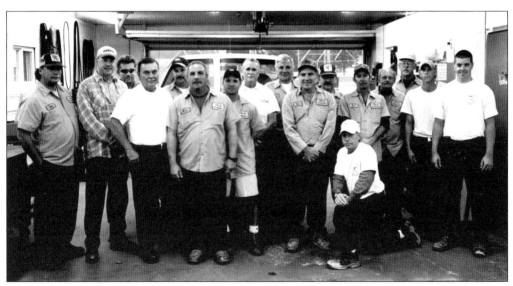

The members of the Florissant Parks and Recreation Department work to maintain the cities beautiful parks and recreational facilities. They are, pictured from left to right, Ron Francis, Doug Shelley, Dave Strunk, Superintendent Bob Laramie, Todd Waldbridge, Mile Fulhorst, Jason George, Jam Jabbie, Dennis Brockmeyer, Mike Krankeola, Larry Peacock, Tim Lemp (kneeling), Rick Trieber, Mike Capps, Archie Williams, and Matt Foskett. (Photo by John A. Wright.)

One of the major assets of the area is the Ferguson–Florissant School District's 100-acre "Little Creek Wild Life Area," which has hiking trails, classrooms, a nature museum, a family cemetery, and a log cabin dating back to the 1800s. Pictured here is a Saturday sheep shearing demonstration for residents and children. (Photo courtesy of the Mercantile Library.)

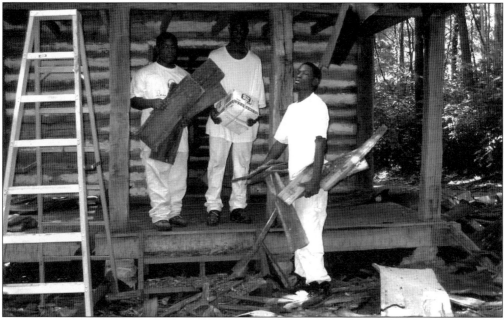

These young men, from Special School District's North County Technical School in Florissant, are working on restoration of the 1850s log cabin at the Little Creek Wild Life Area. Projects of this nature not only help the school district, but provide students with hands-on experiences. (Photo courtesy of the Special School District of St. Louis County.)

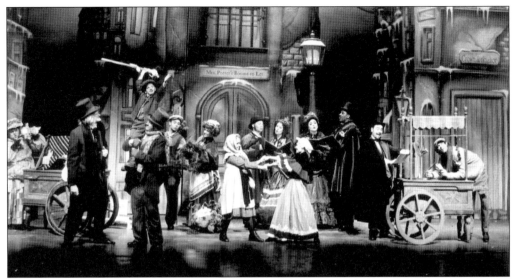

Throughout the year the board of directors of the Florissant Fine Arts Council brings to the community exciting and enjoyable programs. These programs include the St. Louis Symphony performances, band concerts, dances, and Metro Theatre Circus workshops, to name a few. Florissant residents and visitors can find high quality theatrical productions at the Egan Center, in the 600-seat theatre. The Hawthorne Players, Alpha Players, and St. Louis Family Theatre, along with others, have found the theatre an ideal location for their productions. (Photo courtesy of the Florissant Fine Arts Council.)

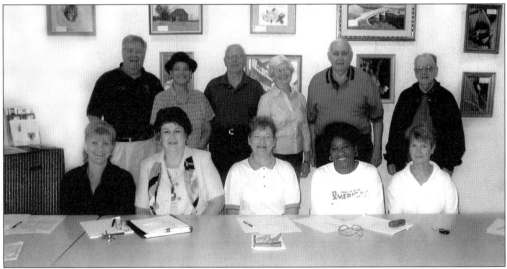

The board of directors of the Florissant Fine Arts Council have the responsibility to foster, promote, and encourage the existing cultural and educational organizations of the City of Florissant and its surrounding area, and to establish new cultural and educational activities. The present council board members are, pictured from left to right, (front row) Marilyn Gulotta, treasurer; Vicky Egan; Jean Springmeier; Dolores Penton; and Suzanne Eagan; (back row) Gary Gaydos, Florissant Civic Center Theatre manager; Madelyn Egeston; Tony Delio, president; Wilma Weinold, secretary; Mel Watkins; and Jack Reed. Behind the board members are some of the pictures on display in the Egan Center Gallery. (Photo by John A. Wright.)

The Valley of the Flowers Festival, which occurs the first weekend in May, is the city's oldest festival. Thousands are drawn to the parade and event each year. It began in 1963, when community leaders were looking for a way for the city to retain some of its identity and proud heritage. A committee comprised of representatives from every facet of the community is

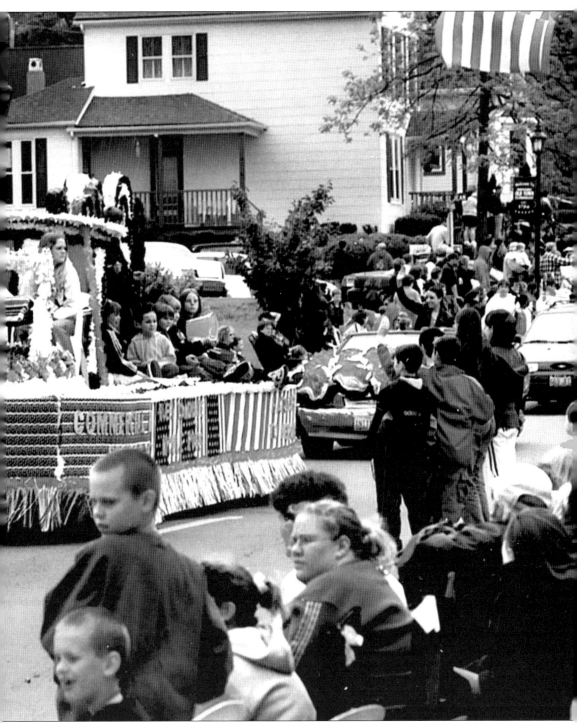

involved in its supervision. Proceeds from the event are shared by participating organizations. During the first year of the festival, the flowering crab was made the official tree of Florissant. Thousands were planted and they continue to bloom each year. (Photo courtesy of the Valley of the Flowers.)

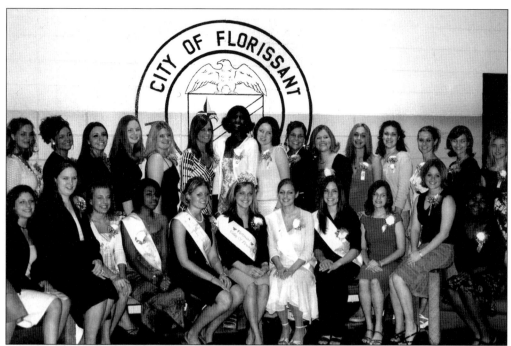

One of the major events of the Valley of the Flowers Festival is the crowning of the queen. These young ladies were contestants and finalists in 2003. (Courtesy of the Valley of the Flowers.)

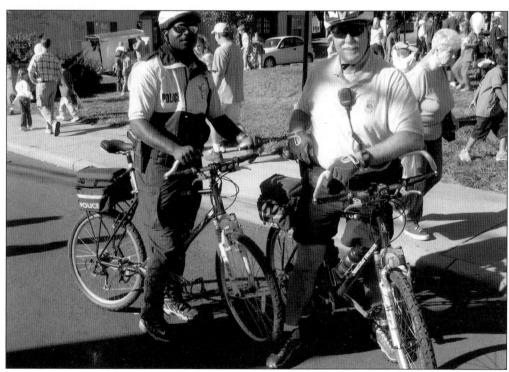

To ensure the safety and enjoyment of the festival by visitors and participants, the Florissant Police Department provides both foot and bike patrols. (Photo by John A. Wright.)

Festival days are filled with events of every nature for the entire family such as rides, entertainment, vendors, displays, and antique cars. (Photo courtesy of the Mercantile Library.)

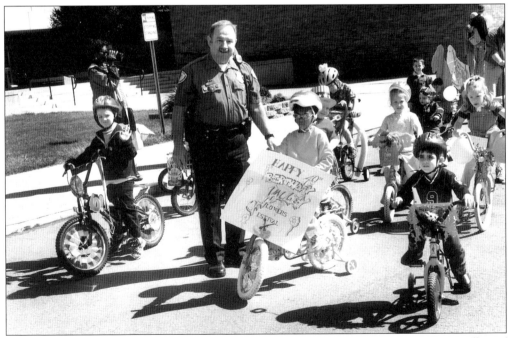

The festival planners spare no effort in making sure all members of the community regardless of age are allowed to participate in festival events. These young people are part of a bike parade celebrating the 40th anniversary of the festival in 2003. (Photo courtesy of the City of Florissant.)

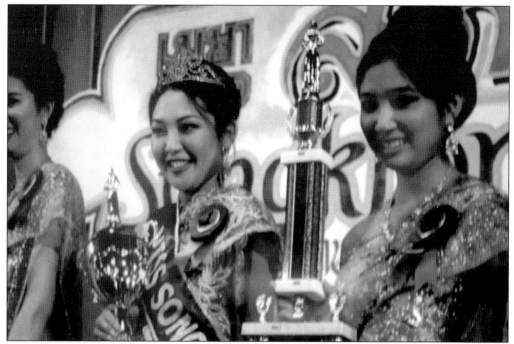

Another major event in the region is the Thai New Year festival and the crowning of the queen at Wat Prasriratanaram at 890 Lindsay Lane. The New Year celebration is a solar event and it marks the beginning of a new astrological year, the passing of the sun from Taurus into Aries. The Thai Songkran Festival (New Year Festival) is filled with food, dance, entertainment, and activities for the whole family. (Photo courtesy of Wat Prasriratanarm.)

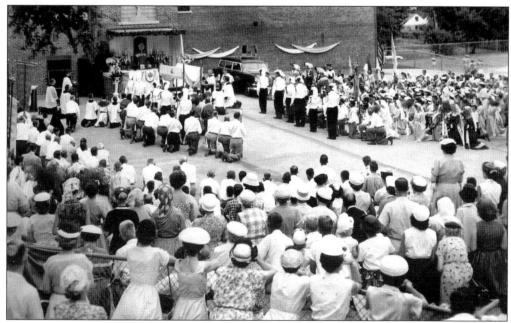

Each year one can find the religious procession on the Feast of Corpus Christi, which started in 1814, dropped for many years, and resumed in 1935. (Photo courtesy of the Mercantile Library.)

Five

OLD TOWN
FLORISSANT

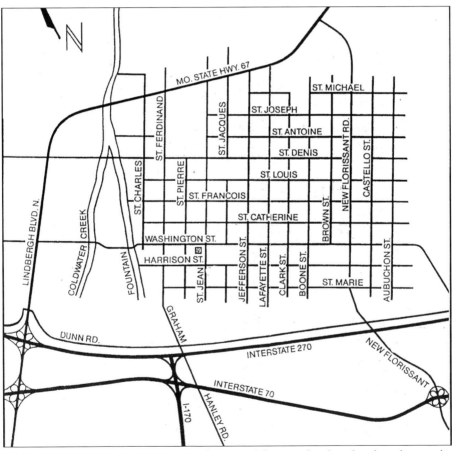

Old Town Florissant is a major contrast to the rest of the city that has developed around it. For the most part, it has retained its quiet village-like character. Within the original 16-block plat the streets have retained the names of saints. When the village was later plotted by United States Government surveyors, street names of prominent Americans and presidents were added. The strong character of this area of the city can be seen in its square blocks, historic buildings, ancient trees, and experience moving on foot. (Photo courtesy of the City of Florissant.)

This area of the city provides a pleasant place to live, spend an afternoon shopping, or have breakfast, lunch, or dinner. Bunkers, in the background, has been a neighborhood watering hole since 1901. (Photo by John A. Wright.)

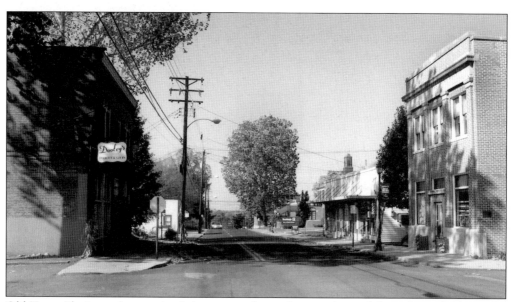

Old Town Florissant has retained the unique flavor that it inherited from the early days. The narrow streets are relatively quiet compared to those outside the area. Many of the original buildings and homes still remain and are used today. (Photo by John A. Wright.)

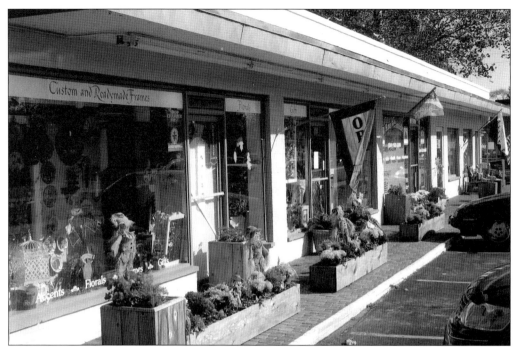

All along rue St. Ferdinand one can find numerous small shops, such as the one shown here, to provide shoppers with a unique shopping experience. (Photo by John A. Wright.)

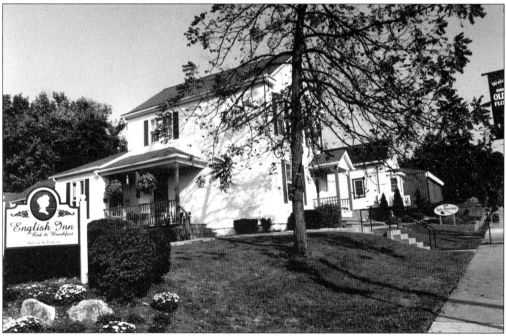

For individuals looking for a weekend getaway or mini vacation, the English Inn Bed and Breakfast, at 405 rue St. Francois, provides lodging 50 weekends a year, along with murder mystery dinners, English tea, and yoga classes. The parlor and dining room facilities are available for various activities. (Photo by John A. Wright.)

Dooley's Florist, at 690 rue St. Francois (c. 1880), operated by Patricia Sosa, the daughter of John Dooley, offers original creations in fresh, dried, and silk flowers, plus gift items. The shop will make deliveries. John Dooley acquired the property from the estate of Stephen Wiehaupt after his death, in 1958, for a flower shop. For over 120 years this building has been owned by only two families. Appleby's Flower Shop, at 406 rue St. Francois, is another florist in Old Town that does an outstanding job. (Photo by John A. Wright.)

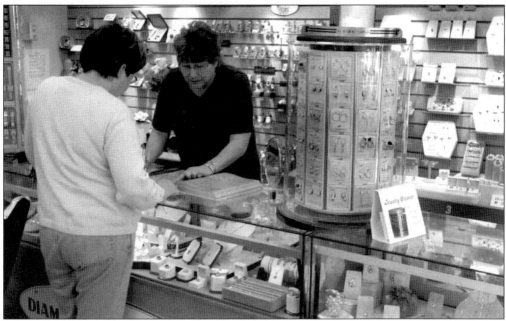

One of the reportedly best jewelry stores in North County is Don Henefer Jewelers, at 512 Florissant in Old Town. The shop offers incredible shopping with the works of true masters of the jewelry industry. (Photo by John A. Wright.)

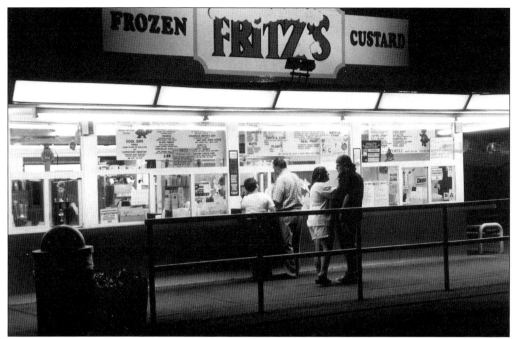

Fritz's Frozen Custard, at 1055 rue Saint Catherine, has been a North County favorite for years. Customers come from miles around during the season for their world famous Turtle Sundae. (Photo by John A. Wright.)

No morning or day would be complete without fresh pastry from Old Town Donuts or Helfer's Pastries. Old Town Donuts, at 508 North Florissant Road, was voted one of the top 10 donut shops in the St. Louis area. Helfer's, at 380 rue St. Ferdinand, offers a variety of breads, muffins, desserts, breakfast pastries, wedding cakes, and all-occasion cakes. (Photo by John A. Wright.)

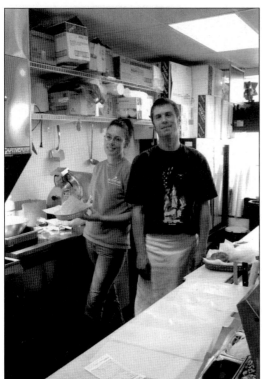

Local residents looking for excellent fast food at a reasonable price head for City Diner at 1060 rue St. Francois, or Crisellyn's Café at 392 rue St. Ferdinand. Both offer soups, sandwiches, and daily specials. Crisellyn's offers children's tea parties, box lunches, and a private room for special use. Jim Stout and Melony Wedig, pictured here at the City Diner, are known to give outstanding service. (Photo by John A. Wright.)

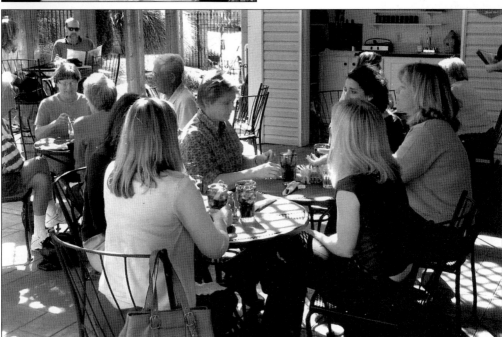

Valley Bistro and Wine Garden at 411 rue St. Francois, Hendel's Market (c. 1873) at 599 rue St. Denis, and Bunkers at 297 rue St. Francois offer outstanding dining. The customers here are enjoying a lunch on the outdoor patio at Valley Bistro, where everything is prepared to order whether it is breakfast, lunch, or dinner. (Photo by John A. Wright.)

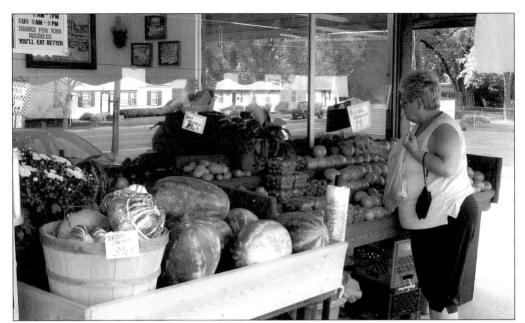

Old Town's only produce market, J. Goeke Produce Outlet at 300 rue St. Ferdinand, offers fresh fruits and vegetables year round everyday of the week. (Photo by John A. Wright.)

Residents find pleasure playing tennis in the two-acre Tower Court Park at New Florissant Road and Washington Street, where four of the community's eighteen lighted tennis courts are located. The 1850s log cabin and Old Narrow Gauge Station discussed on the next page are also found at the park. (Photo by John A. Wright.)

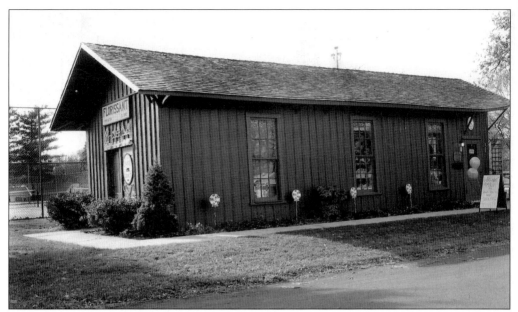

This Narrow Gauge Railroad Station, built in 1878 and located in Tower Court Park, now serves as a candy store. It was moved to this location and restored by Historic Florissant when threatened with demolition because of the widening of St. Ferdinand-Graham Road. (Photo by John A. Wright.)

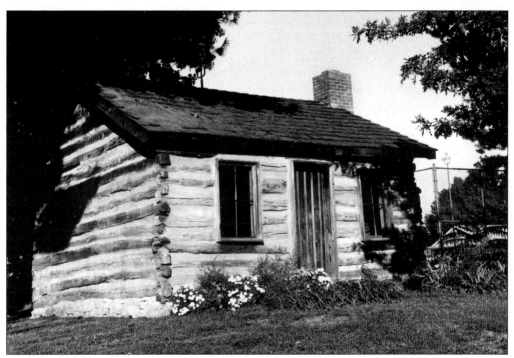

The Florissant Valley Historical Society and the City of Florissant can be credited with saving this 1850 log cabin in Tower Court Park. (Photo by John A. Wright.)

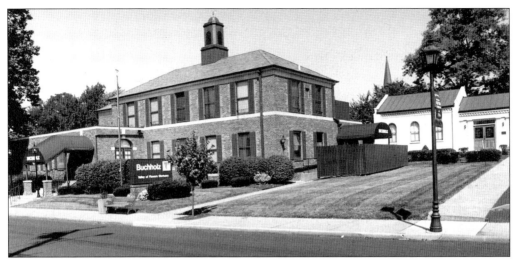

This building that once housed city hall is now Buchholz Valley of the Flowers Mortuary. It has maintained its original style and architecture that blends in with the other buildings in the community. The small white building to the right, that once served as the city's first city hall and fire station and later as a public library, is now used as a senior citizen's center. (Photo by John A. Wright.)

The City of Florissant provides a complete meal to seniors for $2.50 at the Senior Center, located at 621 rue St. Francois. It also provides F.L.E.R.T. (Florissant Local Elderly Resident Transportation) free for senior residents and residents with disabilities. Income tax assistance, senior events, senior information, referral service, golden age discount program, senior clubs, and senior events are also among the services provided to senior citizens. (Photo by John A. Wright.)

Old Town Florissant has a number of historic homes, and since many individuals long for the peaceful pace of life in Old Town Florissant, it is becoming harder and harder to find a home on the market. Because of the high demand for the area, a number of individuals are having custom homes built on vacant lots similar to the one shown here. (Photo by John A. Wright.)

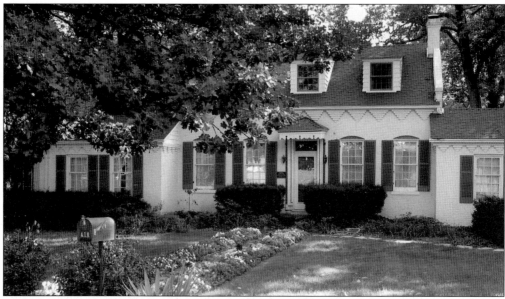

This home, at 410 Harrison Street, was constructed in 1840 and on its nomination for the National Register was called the finest example of German style architecture in the area. A number of additions have been made to the house over the years, such as to the second story, sides, and back, but the character has remained unique. The small central core of the house is original construction. The brick exterior has a fanciful, toothed cornice that is unique to Florissant for weight support. The home was built by Dr. Samuel Magill, who served as Justice of the Peace from 1814 to 1819, and as a state legislator in the early 1800s. He was also one of the delegates to the State Convention for Andrew Jackson in 1828. (Photo by John A. Wright.)

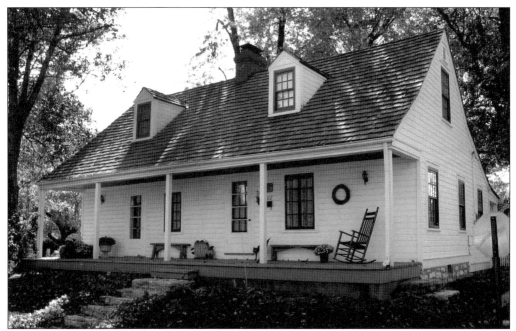

The Auguste Aubuchon House, at 1002 rue St. Louis, was built around 1800 and has been described by some as the jewel of Florissant architecture. This horizontal log construction, now covered with siding, originally consisted of two rooms with a loft above. One of the last families to own the house was the Moellerings. Rita Moellering was one of the first women to play in major league baseball for women in the 1940s. (Photo by John A. Wright.)

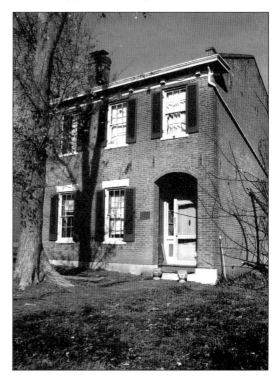

This brick home (c. 1850), at 603 rue St. Denis, was built by Auguste Aubuchon and saved and restored by Historic Florissant, Inc. When Auguste was twelve years old, he joined three others and established a trading post with the Utes Indians—the first post established by whites in Utah. Auguste served as a guide to John Fremont as part of a reconnaissance party, and under Fremont in the Mexican War in the California Battalion. After his death his widow received a pension of $8 a month because of his services. The home was saved from being destroyed and restored by Historic Florissant, Inc. (Photo by John A. Wright.)

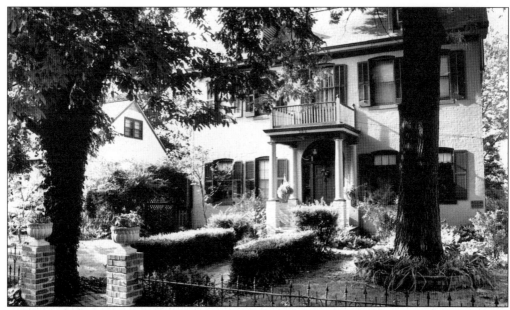

The Montaigne House, at 306 rue St. Louis, was built by Joseph Montaigne in 1834. There are several stories on how he obtained the money to build the house. One story says he bought a lucky raffle ticket for 25¢ and another states that he won big gambling. The house remained in the family until 1956. The second story was added around 1900 when it received its present German appearance with Greek revival and Creole overtones. (Photo by John A. Wright.)

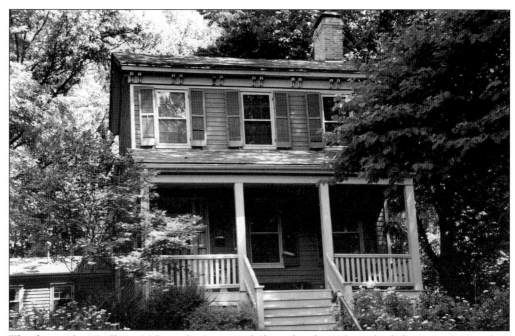

This house (c. 1845), at 805 rue St. Louis, is believed to have been built by Louis R. Band. It was once owed by Edward Bates, the attorney general for President Abraham Lincoln, and later by John and Henrietta Kehrman. John was an engineer on the Narrow Gauge Railroad. (Photo by John A. Wright.)

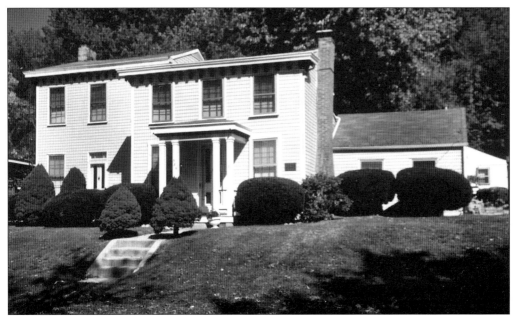

This home is described in the National Register nomination as "one of the finest Greek Revival examples of architecture in the area." It was built around 1860 and named for its previous owners, Castello and Belleville. Some of its restoration was assisted by the Landmarks Commission and the city council, who purchased from the owner a façade easement, with the provision the money would be used for restoration of the façade. (Photo by John A. Wright.)

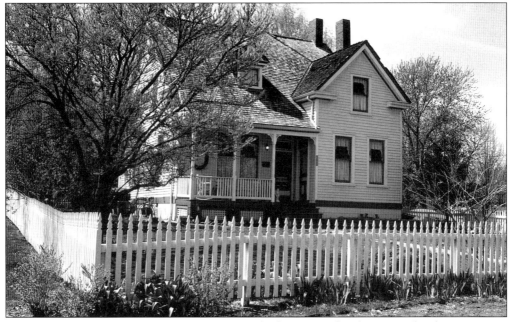

This frame home, at 990 rue St. Francois, was built in 1912 by the Peters family, prominent Florissant residents. It was once an eyesore, but was saved from being demolished by Historic Florissant, Inc., and is now on the National Register of Historic Places. The home is now owned by the Siebe Family. (Photo courtesy of the City of Florissant.)

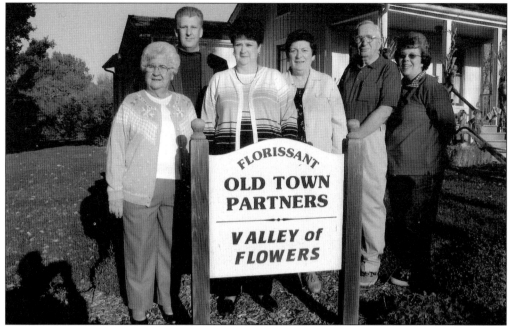

The Valley of the Flowers Board of Directors Old Town truly believe Old Town is an attractive area where persons experience a stable, healthy community with a rich, cultural heritage, and its workers and volunteers are committed to keeping that belief a reality. The directors are, pictured from left to right, Sharon Gettemeier, Jerry Ahlert, Vicky Egan, Geri Debo, Dick Vorwald, and Mary Gettemeier. The 1860 French architecture home in the background is owned by Florissant Old Town Partners and located in Coldwater Commons Park (Photo by John A. Wright.)

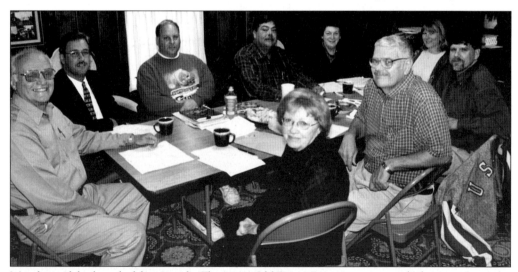

Members of the board of directors for Florissant Old Town Partners meet regularly to carry out the goals of the organization. Those goals are to promote Historic Old Town community stabilization, continue commitment toward community cultural diversity, enhance Historic Old Town Community infrastructure, and improve Historic Old Town awareness. Members of the board are, pictured from left to right, Joe Schulte, John Caravelli, Bill Olwig, Don Zykan, Geri Debo, Jean Kohnen, Mark Carpenter, Steve Frank, and Florence Ragaini. (Photo by John A. Wright.)

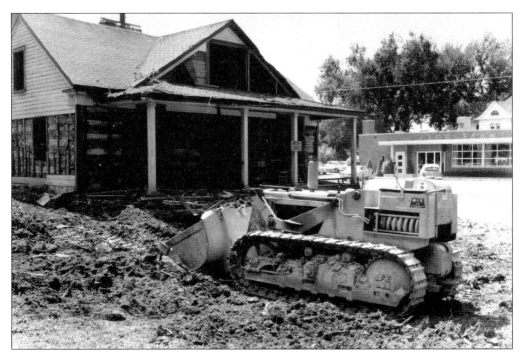

Before Historic Florissant and Old Time Partners became involved in historic preservation, a number of old homes were destroyed. Through the work of both organizations homes are being saved and renovated, like the one pictured here at the bottom. (Top photo courtesy of the City of Florissant and bottom photo by John A. Wright.)

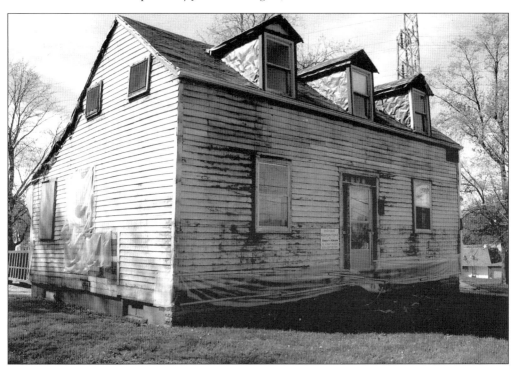

The 10-acre Coldwater Commons Park, located at St. Charles, St. Denis, and rue St. Francois, has been preserved by the city as open space. The park is adjacent to Coldwater Creek, on which banks the original village was plotted, as well as the historic Shrine below. The park has an old-style gazebo with walkways leading around a natural setting with trees of many varieties. (Photo by John A. Wright.)

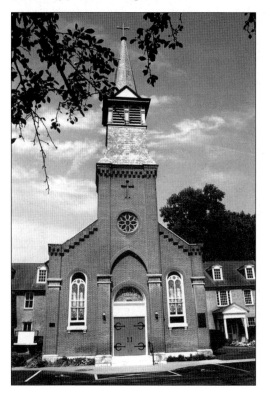

Old St. Ferdinand's Shrine, built in 1820, is the oldest Catholic Church building between the Mississippi River and the Rocky Mountains. Father DeSmet, beloved Black Robe of Indian nations, was ordained at the church on September 23, 1827. The building is no longer used as a church and is maintained by non-sectarian Friends of Old St Ferdinand. When the church was almost destroyed by fire in 1966, the people of Florissant raised almost $100,000 to restore and preserve it for future generations. It is open Sundays from 1 p.m. to 4 p.m., April through December. No admission charge. (Photo by John A. Wright.)

The St. Stanislaus Historical Museum Society, Inc. is now located in the Old St. Ferdinand School, on the grounds of the St. Ferdinand Shrine. On display on the second floor of the school are many artifacts that were once housed in the Rock Building at St. Stanislaus on Howdershell. The display includes many Native American exhibits and period furniture. (Photo by John A. Wright.)

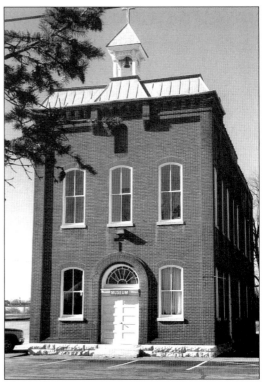

This silver serving set is one of the many artifacts on display in the museum at the school. (Photo by John A. Wright.)

This Spanish Land Grant Park, bound by St. Ferdinand, St. Denis, St. Charles, and St. Louis, was a gift from the Spanish government to the villagers for a church, burial, and parade ground. A number of the early pioneer families lie here in the park in unmarked graves. (Photo by John A. Wright.)

One of the newest additions to the city's park system is Davison Park, acquired in 2001. It honors Rosemary Straub Davison, who was an elected member of the Board of Freeholders, and who wrote a new charter for the city. She served as city clerk for 17 years, a committee woman for the Florissant Township, and was a founding member of Missouri Heritage Trust, Florissant Valley Historical Society, Friends of Old St. Ferdinand Heritage Foundation, Friends of Brush Creek St. Peters Church, and Historic Florissant, Inc. This vest pocket park has a lighted gazebo and is used for mini concerts, weddings, and special events. (Photo by John A. Wright.)

Old Town Wedding Chapel (c. 1895), at 646 rue St. Francois, was the first Protestant church in Florissant. It was known as the Union Church. Throughout the years it has served Baptists, Methodists, and Presbyterians. From the records it appears there were no regular services. Church was held whenever the minister showed up. The church was acquired by the Presbyterians in 1948 and used by them until their new church at Charbonier and Lindbergh was completed. The church is now available for weddings and receptions. (Photo by John A. Wright.)

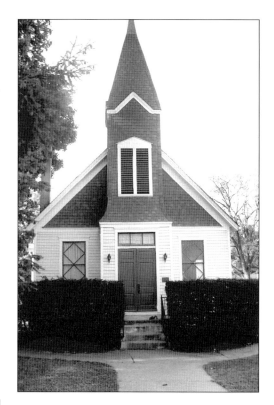

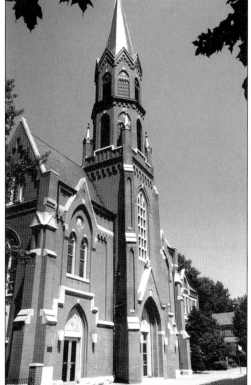

Sacred Heart Parish Church and School has served the Florissant community since 1866. The school today has approximately 350 students per year in the first through eighth grades, and a faculty of over 20 professional educators. The Rectory, dedicated in 1924, is still in use today. (Photo by John A. Wright.)

Combs Elementary School, pictured here, was built in the 1950s to replace the old St. Ferdinand Public School, which was built in 1876. It is rated among one of the highest achieving schools in North St. Louis County. The first public school in the community began in 1845, when an academy was established for students in the first grade, up to high school. The academy was supported by two-thirds of the revenue derived from leases of the St. Ferdinand commons. (Photo courtesy of Combs Elementary School.)

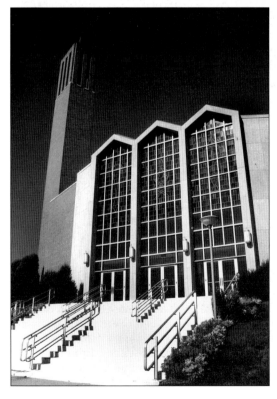

Atonement Lutheran Church is one of two churches in Old Town. Its school opened in 1956 with a kindergarten and the first four grades. Another grade was added each year after that, with the eighth grade added in September 1960. The school today remains an important part of the church's outreach to the Florissant community. It provides a high-quality elementary educational program grounded in the Christian faith. (Photo courtesy of the City of Florissant.)

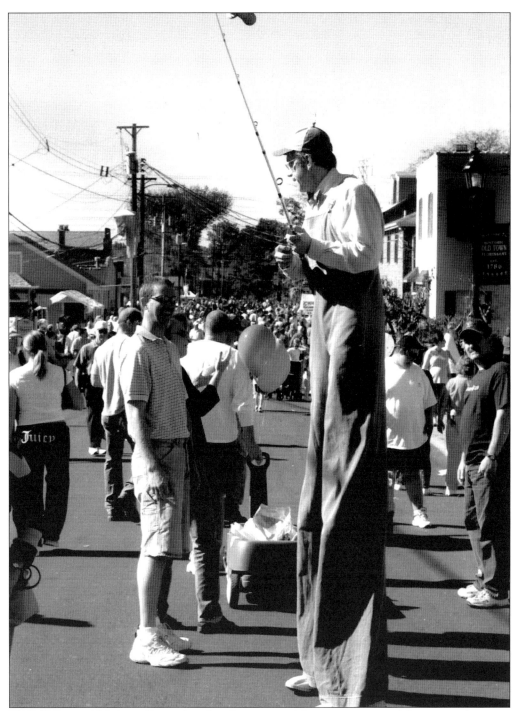

The Florissant Old Town Festival in October is one of the major events of the year and attracts thousands to the city. Rue St. Francois is closed off in Old Town, while the festival activities celebrate the rich heritage of the early French, Spanish, and Irish ancestors of the city. Each heritage grouping has an area where there are activities pertaining to that culture. (Photo by John A. Wright.)

The festival is filled with dance, music, food, cultural displays, exhibits, rides, an automobile show, and everything that makes for a great day. (Photo by John A. Wright.)

Besides the food and rides, the festival always allows time and opportunity to those who like to shop for something old or something new at Missouri Mercantile, Down Memory Lane, Florissant Old Town Market Place (with 22 vendors), Village of the Blue Rose, Old Town Antiques and Collectibles, Sadie's Interiors, Rare Coin Galleries, Korte's, Frame Fair, Sports Dream Card Shop, or Silver Moon Stenciling. (Photo by John A. Wright.)

Six
FLORISSANT TODAY

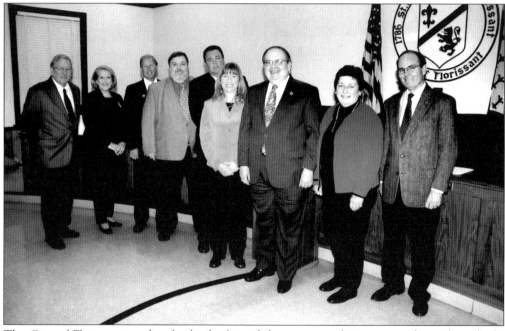

The City of Florissant, under the leadership of the mayor and nine council members, looks forward to the future as it builds on the community's rich and proud past. The citizens take great pride in knowing that their city is recognized as one of the safest communities west of the Mississippi River. It has affordable housing, nationally recognized schools, modern shopping facilities, and varied entertainment and leisure activities. Florissant is located just a few minutes from the airport and a short distance from downtown St. Louis, the Gateway Arch, and Clayton, where the county government center is located. Pictured here are the mayor and council members, from left to right, John Moran, Karen McKay, Mark Schmidt, Tim Lee, Dan King, Nancy Lubiewski, Mayor Robert G. Lowery Sr., Geri Debo, and Tom Schneider. (Photo courtesy of the City of Florissant.)

When he assumed the office of mayor, Robert G. Lowery Sr., brought with him excellent credentials and many years of outstanding community service. He, with his council members, provides leadership for the seventh largest city in the State of Missouri, and the largest city in St. Louis County. Before being elected mayor, Lowery served as chief of the Florissant Police Department, where he had quickly moved up through the ranks. While chief of police, he served as commander of the Major Case Squad of Greater St. Louis, where he is credited with achieving one of most successful clearance rates on record with regard to murder cases. Lowery has received numerous awards for his work in the community and has been recognized at local, state, and national levels. (Photo courtesy of the City of Florissant.)

The Florissant Government Building, at 1005 rue St. Francois, is open Monday through Friday for citizens and those seeking housing in the community. The government building accommodates the Housing Resource Center, which provides home buyers and renters information about available housing opportunities in Florissant, as well as city amenities. The government building also houses City Cable TV 10, as well as the Community Development Office, which provides assistance to the disabled and homeless, and funding for a variety of home improvement loans. (Photo courtesy of the City of Florissant.)

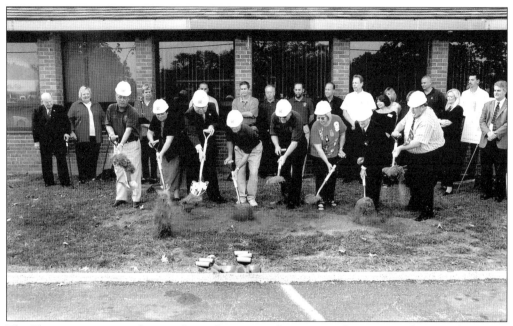

The Florissant mayor and council members are making great efforts, not only to work for new construction for the betterment of the community, but to maintain the quality of the existing facilities. In this photograph they are conducting a groundbreaking ceremony for improvements at the Florissant and Eagan Centers. (Photo courtesy of the City of Florissant.)

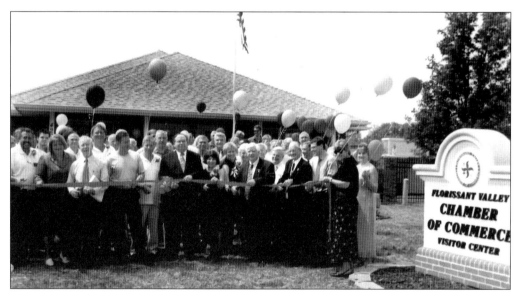

Mayor Lowery is shown cutting the ribbon on the new Florissant Valley Chamber of Commerce building at 420 W. Washington Street. The Florissant Valley Chamber of Commerce was chartered in 1955 as the Florissant Chamber of Commerce the predecessor of the Florissant Businessmen's Association. The City of Florissant works with the chamber of commerce to further the economic development of the city. The chamber's trade area has grown beyond the City of Florissant to include the cities of Blackjack, Hazelwood, and the unincorporated Spanish Lake area. (Photo courtesy of the Florissant Valley Chamber of Commerce.)

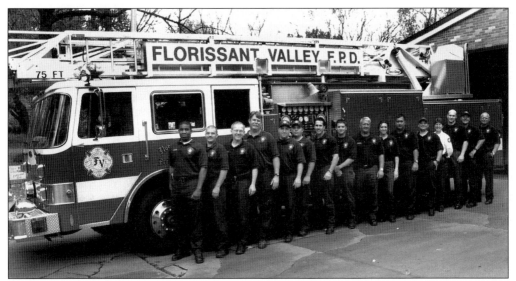

These firemen are part of the 60-member team of the Florissant Valley Fire Protection District. The members and their chief, John Wheadon, are responsible for the 28,000 households and 1,500 businesses in the 22 square-miles of the district. They are, pictured from left to right, Cliff Robinson, Russ Kleffner, Dave Woytus, Tom Stine, Frank Lipski, Marc Bilyeu, Joe Stewart, Jason Dauster, Greg Behlmann, Shari Lewis, Bob Burkes, Steve Votaw, Kim McKeena, Jim Crowley, Terry Cavaness, and Dan Terbrock. In 2003, the department's firetrucks had 2,779 calls and their ambulances had 5,997 calls. (Photo by John A. Wright.)

The fire department played a major role in rescues and clean-up efforts after the flood of 1993, in areas of the district that were impacted. (Photo courtesy of the Florissant Valley Fire Protection District.)

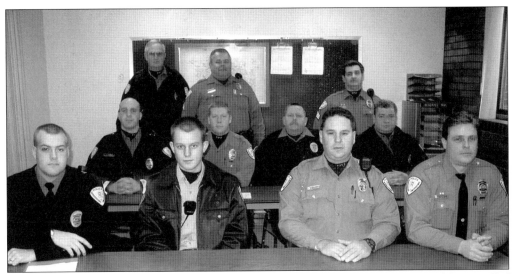

Florissant has a modern police force of 83 full-time commission officers, supported by a staff of 24 civilians. Its department, headed by Chief William G. Karabas, is one of only five departments in the metropolitan area that is internationally accredited by the Commission on Law Enforcement Accreditation for Law Enforcement Agencies. These members of the afternoon shift have just completed a debriefing prior to assuming their duties. They are, pictured from left to right, (front row) Officer Craig DeHart, Explorer Matt Krahl, Officer Andy Quinones, and Officer Brian Bethman, (middle row) Officers Matthew Thompson, Michael Cameron, James Arnold, and Jason Roche, (back row) Officer Gary Thieme, Sgt. Michael Mahaffy, and Sgt. Richard Miller. (Photo courtesy of the City of Florissant.)

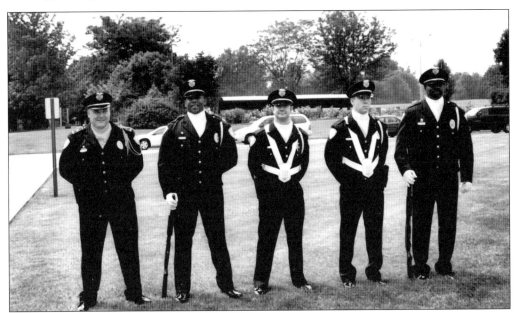

These officers are members of the police department's Honor Guard, they perform at memorial services and special events in the city. They are, pictured from right to left: Leader Sgt. Sean Fagan, and Officers Edward Sharpe, Rich Pfaff, Kevin Boschert, and Jeff Wilson. (Photo courtesy of the City of Florissant.)

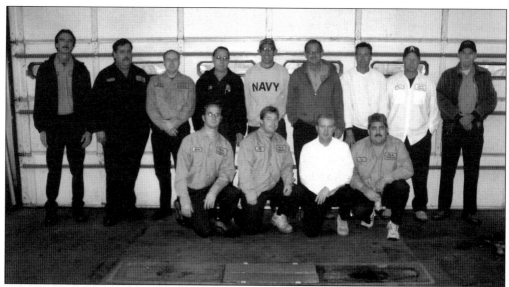

The Florissant Street Department is responsible for maintaining over 160 miles of streets and helping to keep the community an attractive place to live. Some of the men who make this possible are, pictured from left to right, (front row) Bob Krause, Jim Berry, Street Superintendent Gary Meyer, and Ed Renner, (back row) Sam Reeves, Dave Reiter, Paul Gross, Jay Grabowski, Bob Kolbow, Bill Hesselbach, Danny Jost, Kevin Green, and Gordon Steele. (Photo by John A. Wright.)

The city has a number of commissions that enable citizens to become involved in city government. These young people are members of the Youth Commission. The city has over 14 boards and commissions that enable citizens to become involved in city government. These include boards and commissions regarding planning and zoning, traffic, industrial development, landmarks, and historic district, to name a few. (Photo courtesy of the City of Florissant.)

114

The St. Louis County Florissant Valley Library Branch, at 195 South New Florissant Road next to Bangert Park, serves over 60,000 residents of all ages. In 2000, it had a circulation of 337,523 volumes and 233,196 patron visits. The meeting rooms had 83 groups with 547 meetings, and youth programs with 2,793 children attending 119 programs. The City of Florissant Library merged with the St. Louis County Library in 1964. (Photo by John A. Wright.)

The City of Florissant's Media Department operates Channel 10 on the local cable system. The department's mission is to produce professional quality television programs specifically designed to inform and entertain, from a government point of view. (Photo courtesy of the City of Florissant.)

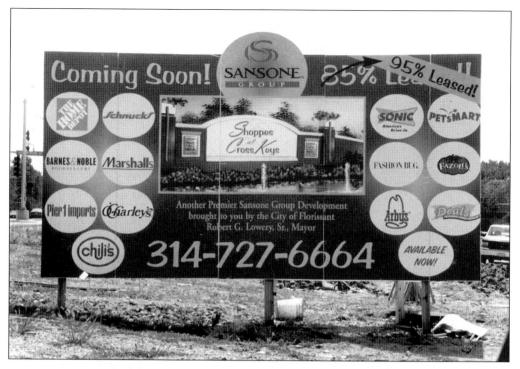

Florissant is growing, improving, and developing its business areas throughout the city. Pictured here is the new development at the Cross Keys Shopping Center at Lindberg Boulevard and New Halls Ferry Road. The city has made a commitment to provide the best of services to its residents. (Photo by John A. Wright.)

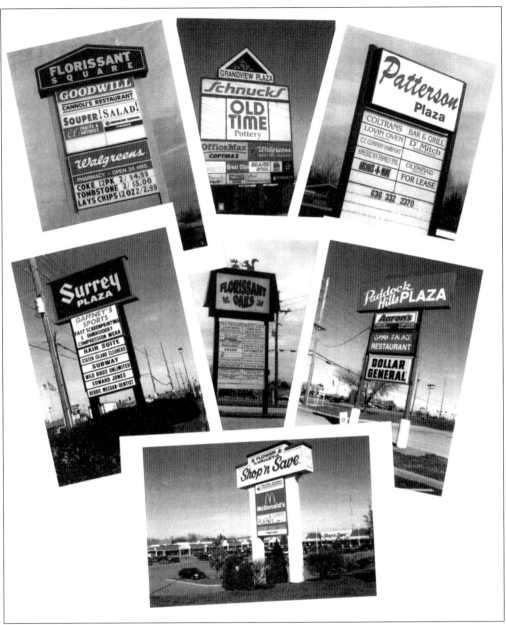

No matter where you live in Florissant, you are never more than a few minutes from a shopping center with major and specialty stores and restaurants with American, ethnic, and international cuisine to fulfill your needs. (Photos by John A. Wright.)

Foley's Wallpaper and Paint Co. has been in business since 1937, and in Florissant since 1962. It still offers the same personal service to the professional, as well as the weekend decorator as it did over 40 years ago. This store, at 740 New Florissant Road South, is operated by Steve Graves, the son of Bill Graves—who purchased the store in 1958 from Morgan Foley of Boston, Massachusetts. (Photo by John A. Wright.)

Fischer's Pro-Line Sports, at 785 New Florissant Road South, has been in the community for 74 years and is known by residents as the place to look for sporting goods and equipment. Jim Fischer, who took over the store from his father, has passed the operation over to his sons Richard and Don. (Photo by John A. Wright.)

Nagle's, at 19 Patterson Road in Patterson Plaza, is an old-time favorite for those looking for unusual gifts and items. To go through the store is an experience. Joseph Nagle took over the store when it was Ben Franklin in the 1970s, and changed the name to Nagle's around 1982. The store is now operated by his son, Michael. (Photo by John A. Wright.)

Today, Florissant is the home of many shops and businesses owned by individuals of all nationalities. The R & R Style Shop, operated by Randy Barnes and Rosalyn Thompson at 3355 Parker Spur Road, has been the first choice for many area residents and well-known celebrities like Ozzie Smith since the early 1990s. (Photo courtesy of Randy Barnes.)

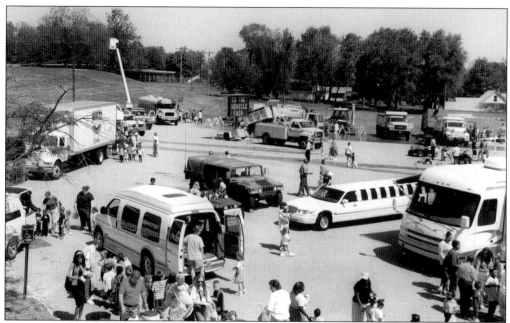

Hundreds come to the city throughout the year for special events, such as the Early Years Conference and The Vehicle Transportation Show for small children. The show acquaints children with the variety of vehicles existing in the world in which they live, and is sponsored each year by the Ferguson–Florissant School District. (Photo courtesy of Janice Williams.)

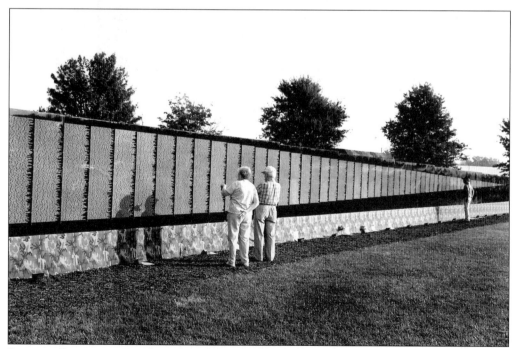

Because of its reputation, Florissant is often chosen for such exhibits as the Vietnam Memorial traveling exhibit, pictured here in Florissant Valley Park. This exhibit drew visitors from all over the region. (Photo courtesy of the City of Florissant.)

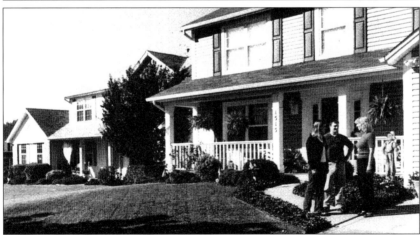

The City of Florissant offers a wide selection of housing from which to choose. Be it historic, gated, single, or multi-family with styles such as ranch or colonial, it's all there. New homeowners can obtain a Home Equity Assurance Program through the city that assures program members the value of their property will not fall below the value established at the time it was registered with the program. (Photos courtesy of the City of Florissant and John A. Wright.)

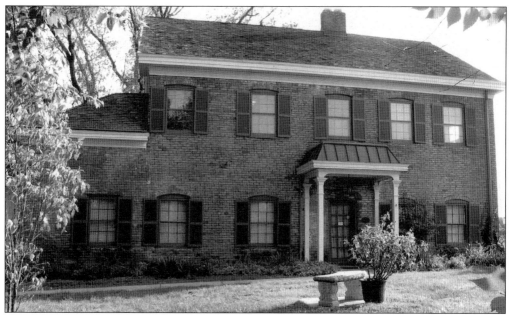

The Gettemeier House, at 1067 Dunn Road, is the office and resource center for Historic Florissant. This house was saved from being demolished by the organization. Since its founding, the organization has saved a number of buildings, including the 1850 Archambault House, The Narrow Gauge Rail Station, the Meyers House and Barn, the Wiese House, the Delisle Building, the Peters House, Log Cabin, and Albers House. Contrary to belief by some, Historic Florissant's properties are not exempt of property or utility taxes. (Photo by John A. Wright.)

Historic Florissant continues to work to preserve the community's historic buildings. The organization was founded in 1969 by five women to rescue endangered buildings in the community. Different from most preservation groups, it is not a membership organization and is open to anyone who shares its values and is willing to work. Current directors are, pictured from left to right, Rosemary Davison, Kay Spring, Mary Kay Gladbach, Elzina Green, Geri Debo, and Nancy Quade. (Photo by John A. Wright.)

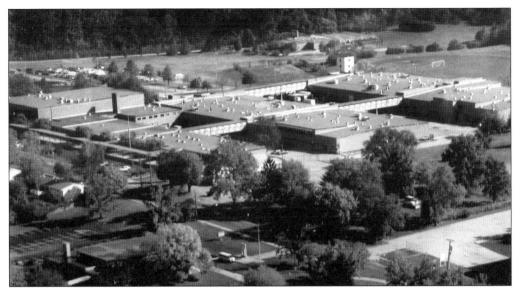

Special School District of St. Louis County provides special education and vocational-technical education to the students of the community. Pictured here is an aerial view of North County Vocational High School at 1700 Derhake Road. The school offers over 25 career programs, ranging from technology to cosmetology, on its 40-acre campus. For those in search of residential treatment for dependent, neglected, abused, abandoned, and emotionally ill children, Marygrove. operated by the Daughters of Charity and the Sisters of Good Shepard, provides services on their 50-acre campus on the Missouri Bluffs at 2705 Mullanphy Lane. (Photo courtesy of Michael Powers.)

Local and area residents are able to further their education at Florissant Valley Community College near the eastern southern edge of the city, through Fontbonne College at the Eagan Center, or St. Louis Christian College at 1360 Grandview Drive. Pictured here are graduates from St. Louis Christian College, which offers accredited two- and four-year degrees. (Photo courtesy of St. Louis Christian College.)

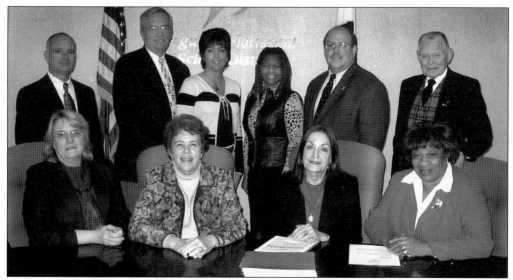

The Ferguson–Florissant School District is responsible for nine educational facilities in the community. In 2003, the district served 6,761 students. Members of the Board of Education and administration are, pictured from left to right, (seated) Leslie Hogshead, president; Nancy Knorr, director; Jeanne Garofalo, director; and Doris Graham, director; (standing) Jeffrey Spiegel, incoming superintendent; E. James Travis, superintendent; Lori Busby, secretary; Gwendolyn Thomas, director; Brian Fletcher, director; and James Clark, director. (Photo by John A. Wright.)

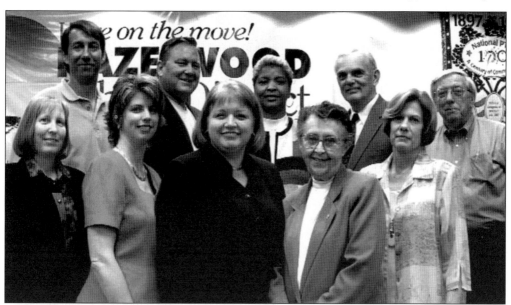

Pictured here are members of the Hazelwood School District Board of Education and administrative team, who provide leadership for six educational facilities in Florissant. In 2003, the district provided services for 3,371 students. The members are, pictured from left to right, (front row) Diane Dowdy, treasurer; Sharon Hepburn, director; Dr. Chris Wright, superintendent; Ann Gibbons, secretary; and Nancee Westcott, recorder; (back row) Robert Berry, director; Mark J. Behlmann, president; Desiree D. Whitlock, director; Robert Baine, attorney; and Joe Donahue, vice president. (Photo courtesy of the Hazelwood School District.)

Halls Ferry Elementary School is one of the latest schools in the community to receive the Blue Ribbon Award for excellence in education from the United States Department of Education. Principal Susan Lark is shown sharing the award with the school's student body and staff. (Photo courtesy of Susan Lark.)

McCluer North Principal Michael Thacker is shown here with some of his students in front of the school's honor wall. McCluer North, an A+ school, has received numerous awards, which include the Red Book Magazine Award, Blue Ribbon Award, and Gold Star Award. (Photo courtesy of Michael Thacker.)

The community is blessed with many outstanding educational institutions, both public and parochial. Former First Lady Barbara Bush is pictured here with former Senator John Ashcroft visiting the Ferguson–Florissant School District's Parents as Teachers program. It was one of only four pilot projects in Missouri. The district program demonstrated success for families of children from birth to age three, and grew immediately to 543 school districts in the state in 1985. By the end of 2004, it will have expanded to 3,300 programs worldwide. (Photo courtesy of Joy Rouse.)

The teachers and staff of Commons Lane Elementary School were praised for their work by United States Secretary of Education Roderick R. Paige. Commons Lane is one of the top achieving Title One schools in the State of Missouri. Pictured with Secretary Paige are, from left to right, Principal Dr. Barbara Wright; Mayor Robert Lowery Sr.; and Ethan Dudenhoeffer, student council representative. (Photo by John A. Wright.)

Florissant has been the destination for visitors from all points of the globe since its beginning. Early Florissant brought to the area the French, German, and Irish. Today, because of the community's rich history and quality of life, visitors from around the world find it a welcoming destination. These visitors from Russia are part of a "Friendship Force" delegation. (Photo courtesy of the City of Florissant.)

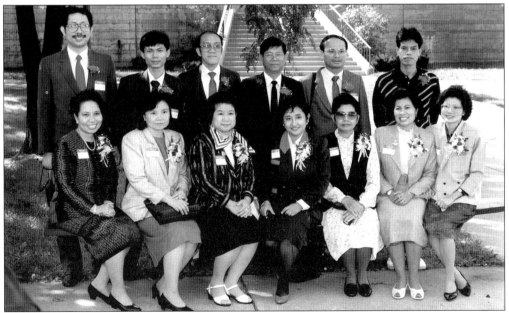

The Thai educators pictured here took part in an educational exchange with teachers and administrators in the Ferguson–Florissant School District. Both spent time in each others' schools sharing ideas and educational approaches. Educational exchanges and visits by foreign educators are common for most schools in the community, because of the rich experiences they provide. (Photo by John A. Wright.)

SELECTED BIBLIOGRAPHY

Davison, Rosemary S., *Florissant, Missouri*, Donning Company Publishers, Virginia Beach, VA, 2002.

Florissant Centennial Committee, *Souvenir Program-Florissant Centennial, 1857–1957*, Florissant Centennial Committee, 1957.

The citizens of Florissant look to the future with great optimism and determination, as they build on the city's proud past with a belief that the city will continue to be a model for the region, state, and nation. With their vision and on-going efforts, there is no doubt the city will continue to be a place where children and adults of all backgrounds and ages will live and work in harmony, in a safe and caring environment. (Photo by John A. Wright.)